SECRET
NEW FOREST

Martin Brisland

AMBERLEY

Acknowledgements

Sincere thanks to Alex Brisland, Hannah Barber, Mike Daish and Julian Porter for their photography and other talents.

This book is dedicated to my wife, Jennifer –
Semper Fidelis

First published 2022

Amberley Publishing
The Hill, Stroud
Gloucestershire, GL5 4EP

www.amberley-books.com

Copyright © Martin Brisland, 2022

The right of Martin Brisland to be identified as the Author of this work has been asserted in accordance with the Copyrights, Designs and Patents Act 1988.

ISBN 978 1 3981 1108 0 (print)
ISBN 978 1 3981 1109 7 (ebook)

British Library Cataloguing in Publication Data.
A catalogue record for this book is available from the British Library.

Typesetting by SJmagic DESIGN SERVICES, India.
Printed in Great Britain.

Contents

Introduction 4

1. Why Is It Called the 'New Forest'? 5

2. The Forest Today 8

3. Managing the New Forest 10

4. Brockenhurst, Lyndhurst, Ringwood and Sway 12

5. Some New Forest Villages 23

6. The North of the Forest 44

7. The New Forest Coastline 49

8. Characters of the Forest 68

9. New Forest Artists and Writers 76

10. The New Forest and War 81

11. New Forest Nature and Wildlife 88

12. New Forest Ghost Stories 93

13. The New Forest's Future 96

Introduction

After a career in education, I was enjoying retirement until a brain haemorrhage in 2017 led to a change in priorities. I now research and write on local history and *Secret New Forest* is my fourth book for Amberley Publishing.

As a child, I loved reading *The Children of the New Forest* (1847) by Captain Frederick Marryat, which is set around Sway during the English Civil War. It is about four orphaned children of a Royalist officer who learn to live in the wild to escape the Roundhead soldiers. Ever since, I have loved exploring this area on my doorstep. The boundaries of the National Park, the two parliamentary constituencies and the New Forest District Council (NFDC) are all a little different, so Totton and others within the NFDC area are included here. 'The Forest' and the word 'inclosures' instead of enclosures, meaning a fenced-off area, are usually used locally and these are the descriptions used in this book.

'And into the forest I go, to lose my mind and find my soul'

– John Muir.

Martin Brisland, author.

1. Why Is It Called the 'New Forest'?

Actually, the 220-square-mile Forest area is not that new and not a traditional forest. Only half is wooded with the rest mainly gorse, heathland, mudflats, coastline and farms.

Created around 1079 as an exclusive royal hunting ground, especially for deer, the Domesday Book of 1086 calls it Nova Foresta or New Forest. On 12 April 1979, the 900th anniversary of the New Forest was marked by the visit of the Queen and Duke of Edinburgh. They visited the Knightwood Oak and planted the nearby Queen's Oak.

DID YOU KNOW?

The Jutes who settled locally after the departure of the Romans named the area Ytene.

In the case of the title 'New Forest', the word 'Forest' was used to describe an area of land that had been 'afforested' (purchased under law) and converted with tree planting into land to be used for royal hunting. It was fiercely protected. Henry of Huntingdon said of King William I: 'If anyone else killed a stag or a wild boar, his eyes were put out.'

The illegitimate William the Conqueror died in 1087 and some accounts say that his bloated corpse would not fit into his stone sarcophagus. According to the Benedictine monk Oderic Vitalis, 'the swollen bowels burst and an intolerable stench assailed the nostrils of the bystanders and the whole crowd'. Maybe King Harold, defeated at the 1066 Battle of Hastings, eventually got his revenge? Local belief was that this was punishment for the crimes committed by William I when he created his New Forest.

DID YOU KNOW?

The Drivers' Map of the New Forest, First Edition 1789, was so named after two of the cartographers. It was the first accurate large-scale map of the entire Forest at 4 inches to a mile. It is approximately 2 metres square.

William I's eldest son, Richard, had been killed by a stag in the Forest in 1081, so his brother William Rufus became King William II in 1087. The story goes that on 2 August 1100, an

arrow was shot by the Frenchman Sir Walter Tyrrell who was the King's best archer. The arrow struck an oak tree and ricocheted off it straight into the chest of the king, puncturing his lung and killing him.

DID YOU KNOW?

Ocknell Pond near Stoney Cross is where Walter Tyrrell was said to have washed the blood of William I from his hands after his arrow killed the king. Every anniversary this pond is said to mysteriously turn red. Some say a black hound called Tyrrell's Dog appears as a death omen.

Sir Walter hot-footed it back to Normandy, never to return, in fear of being charged with the King's murder, crossing the River Avon at a spot still known as Tyrrell's Ford. The tale says that he stopped at a blacksmith's on the way and had his horse re-shod with backwards-facing horseshoes so as to confuse the chasers.

A charcoal burner named Purkis loaded the corpse onto his cart. He took him to Romsey, then via Chandlers Ford to Winchester Cathedral where he was buried with no mass sung or toll bells. William's younger brother went to Winchester, gained control of the Treasury and declared himself the new king.

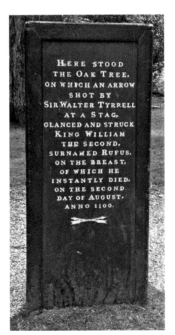 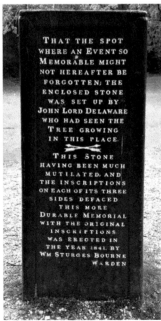 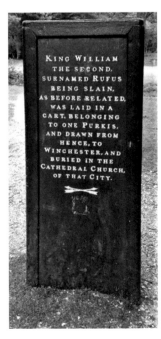

The current William Rufus memorial dates from 1841.

The Rufus Stone at Canterton marks where King William II (nicknamed Rufus due to his red hair) was killed by Sir Walter Tyrrell: 'Here stood the oak tree, on which an arrow shot by Sir Walter Tyrrell at a stag, glanced and struck King William the Second, surnamed Rufus, on the breast, of which he instantly died, on the second day of August, anno 1100.'

The original stone was set up by John Lord Delaware, who had seen the tree growing in this place. This stone, however, was much damaged with the inscriptions on each of its three sides defaced. This more durable memorial with the original inscriptions was erected in 1841, by W. M. Sturges Bourne, Warden.

Some claim that on a summer's evening you may see William's ghost. A red deer is said to appear there whenever a British monarch is about to die. The earliest written account of the regicide by Leyland suggests it may have happened a few miles away near Beaulieu.

Still today the majority of the Forest is Crown land, with King James II the last monarch to hunt there in 1686. The Crown lands passed to the Forestry Commission, today known as Forestry England. Under a 1925 Act, walkers and riders have the right to be on Crown land anywhere in the Forest.

DID YOU KNOW?

The highest point in the Forest is Piper's Wait at 128 metres, near the village of Nomansland.

Above left: Walter Tyrrell pub sign.

Above right: The original Walter Tyrrell pub is now a private residence.

2. The Forest Today

The New Forest has been a Site of Special Scientific Interest since 1971 and its National Park status dates from 2005. It is mostly in south-west Hampshire with a small part in Wiltshire and is one of fourteen national parks. It stretches from Southampton Water in the east to the Avon Valley in the west and from the edge of the Wiltshire Downs in the north to the Solent coast in the south. There are forty-five New Forest National Park boundary markers made mainly from Douglas fir, often in the shape of an oak.

Nearly 67 per cent of the National Park is covered by the historic 'Perambulation'. This is the area in which common rights apply and commoner's livestock can roam freely. Kings Hat is one of around a dozen 'hats' in the Forest. The name is similar to a 'clump' meaning a group of trees on a small hill.

Locally, 'Bottom' means a valley floor. The Forest has a Crow's Nest Bottom, Dead Man's Bottom, Pound Bottom and Slap Bottom.

A 'Castle' in the Forest means a pre-Roman fortification, such as Castle Malwood. Buckland Rings is an Iron Age defensive hill fort near Lymington from *c.* 400 BC now run by Hampshire County Council. It is thought that it was taken by General Vespasian

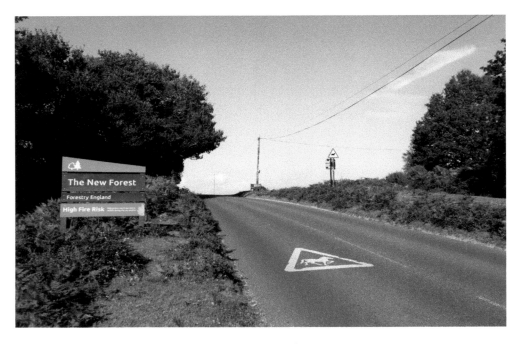

A Forestry England sign. Note the horse on the road marking.

around 43 CE during the Roman invasion. Recent research has identified seven prehistoric dwellings for a community of hunters and farmers on site.

A 'Lawn' in the Forest means a grassy area for animal grazing, for example Balmer Lawn, Mill Lawn, Busketts Lawn and Butts Lawn.

There are four railway stations within it, at Ashurst, Brockenhurst, Beaulieu Road and Sway. The New Forest has sixty-one ancient monuments, 634 listed buildings, seven medieval churches and eighteen conservation areas. It receives an estimated 13.5 million visits a year, supporting around 2,500 jobs. Over 60 per cent of these visits are day visits by people who are local to the National Park.

DID YOU KNOW?

Visitors to the Forest are known as 'grockles'.

The Forest has 141 miles of footpaths for walking and cycling, and 26 miles of coastline. Fox hunting was once allowed in the Forest with the first New Forest Hounds Hunt Ball in 1819.

Admiral Murray was killed in 1901 whilst out hunting and a stone marking Murray's Passage, a safe crossing across a boggy valley that drains into Highland Water, is still visible today.

The area has many attractions including the National Motor Museum at Beaulieu with its exhibition of James Bond cars, and Exbury Gardens, created by the Rothschilds with exotic flowers and fauna from all over the world. The New Forest Show held every July promotes the country lifestyle and the annual New Forest Folk Festival is renowned for its atmosphere.

DID YOU KNOW?

The Forest's area of lowland heath, defined as lying below 1,000 feet, is the largest remaining in Western Europe.

DID YOU KNOW?

The Forest's only railway junction is at Lymington Junction near Brockenhurst.

3. Managing the New Forest

Medieval Forest laws strictly prohibited any interference by local peasants, or 'commoners', with the native animals of the area. Commoners were not allowed to fence their properties, because a fence would interfere with the free-running deer and boar. In return, the commoners were given the rights to graze their own ponies, cattle and pigs on the open Forest.

In 1924 the Forestry Commission officially took over the management of Crown lands in the Forest.

DID YOU KNOW?

An old rural rhyme says, 'Oak and maple dry and old, help keep out the winter cold.'

Locally, the Verderers, Agisters and Commoners act as the judges, police and land users of the Forest. The Verderers' name derives from the Norman French for green. There are ten unpaid Verderers – half government appointed and half elected by commoners. They set the Forest bylaws, such as the fee for animal marking. Today most animals are freeze branded rather than hot branded. Cattle are given ear tags.

The Agisters' name derives from Norman French meaning 'to receive payment'. Five Agisters spend much of their time on horseback looking after the animals of the Forest. Each Agister has a 'beat' to patrol and sadly will deal with pony deaths from vehicle collisions. They run the annual pony round-up or 'drift'.

The Commoners gained protection under the New Forest Act 1877. It confirmed their historic rights and reconstituted the Court of Verderers as their representatives. The historic rights of Commoners were to turn horses, cattle and rarely sheep out into the Forest to graze, to gather fuel wood, to cut peat for fuel, to dig clay, and to turn out pigs for sixty days between September and November to eat fallen acorns and beechnuts. Pigs can eat acorns without a problem, whereas they can be poisonous to ponies and cattle.

Around 800 Forest properties have Common Rights. A Commoners Defence Organisation was founded in 1909. At present over 500 commoners graze around 8,000 ponies, cattle and donkeys around the year. Some of the New Forest's Commoners featured in the 2018 Channel 4 TV series *A Year in the New Forest*. Keepers work for

the Forestry Commission to monitor the deer population and keep an eye on the state of fences, gates, drains and ditches. Each keeper has a beat and gets to know the local Commoners.

The New Forest National Park Authority employs rangers who work to increase the understanding of the local landscape, culture and wildlife and manage community projects. They attend many local events and activities organised by Forestry England, the New Forest Heritage Centre and others. They may be seen at places such as Bolderwood Deer Sanctuary, the Reptile Centre or Lepe Country Park.

4. Brockenhurst, Lyndhurst, Ringwood and Sway

Over 34,000 people live within its boundaries but only three settlements within the National Park have over 3,000 people. The largest is Brockenhurst followed by Sway and Lyndhurst, so let's take a closer look at them along with Ringwood a large town on its edge.

Brockenhurst

Forest place names from the Saxon and Viking period (410–1066 CE) include Brockenhurst, meaning badger wood. Brockenhurst was mentioned in the Domesday Book of 1086 as Broceste and was once declared 'Britain's Most Beautiful Place to Live'. This may explain why the average 2021 property price in and around Brockenhurst was £1,009,225. Its railway station was used to film a 1974 remake of *Brief Encounter* starring Richard Burton and Sophia Loren. The Watersplash is a much-photographed ford crossing. The Filly Inn, just outside Brockenhurst, is opposite a former German POW camp.

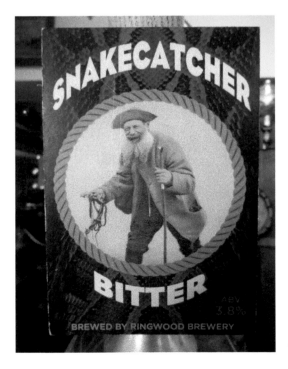

Brusher Mills has a locally brewed beer.

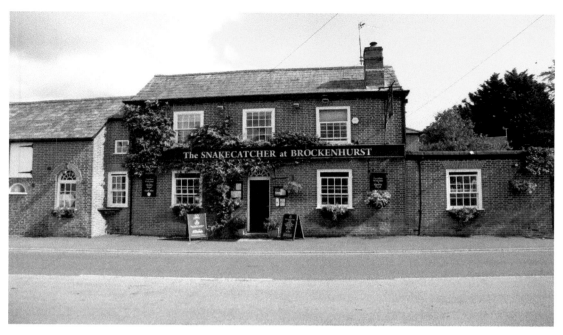

Brusher liked a rum at the Railway Inn, now 'The Snakecatcher' pub.

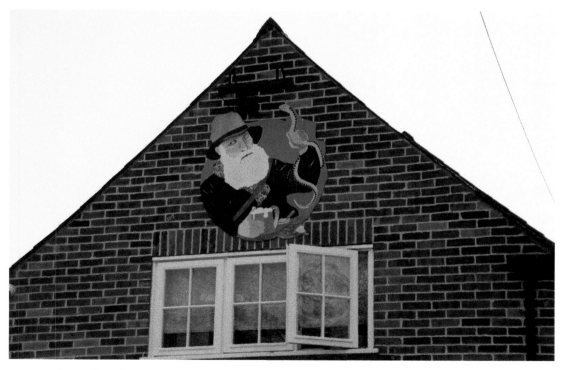

Brusher Mills and trademark snake.

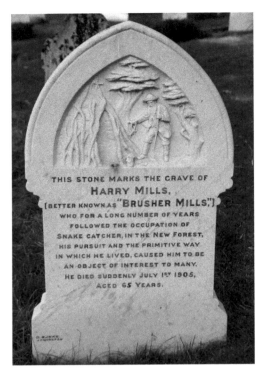

THIS STONE MARKS THE GRAVE OF
HARRY MILLS,
(BETTER KNOWN AS "BRUSHER MILLS",)
WHO FOR A LONG NUMBER OF YEARS
FOLLOWED THE OCCUPATION OF
SNAKE CATCHER, IN THE NEW FOREST,
HIS PURSUIT AND THE PRIMITIVE WAY
IN WHICH HE LIVED, CAUSED HIM TO BE
AN OBJECT OF INTEREST TO MANY.
HE DIED SUDDENLY JULY 1ST 1905,
ACED 65 YEARS.

Left: His gravestone in the churchyard of St Nicholas, Brockenhurst.

Below: A filly is a female pony under four years of age.

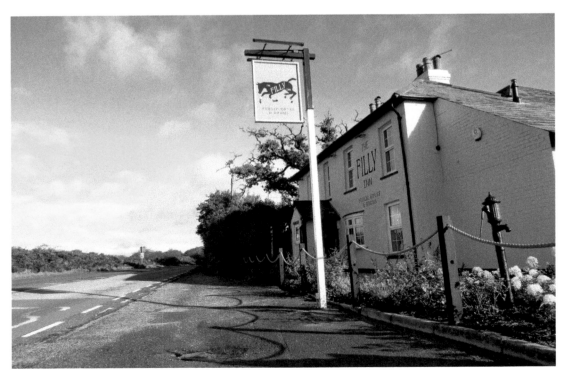

DID YOU KNOW?

At Easter 1979, a gun fight took place at Ivy Wood, near Brockenhurst, between rival chapters of Hells Angels. Seventeen were later convicted of riotous assembly and one for attempted murder.

The Rhinefield House hotel website says that in December 1648 Charles I met Oliver Cromwell in a hunting lodge on the estate. Charles was beheaded in London on 30 January 1649. Rhinefield was built in 1885 with a gift of £250,000 given to a daughter of the family who owned Eastwood Colliery in Nottinghamshire which featured in novels by D. H Lawrence. It has a smoking room that recreates the Alhambra Palace in Grenada, Spain.

The seventeenth-century Roydon Manor was purchased by Edward Morant in 1771, not long after his acquisition of Brockenhurst House. It was included by the Revd Henry Comyn in his 1817 *Directory of Life in the Parishes of Boldre and Brockenhurst.* Bluebells, primroses, marigolds and daffodils can be seen in season at Roydon Woods Nature Reserve.

Created by 1484 and replacing a previous one at Lyndhurst, New Park was used for deer hunting. Roman coins have been found there. In 1666, after his return from exile in France, Charles II made New Park his favourite hunting lodge. The acorns and oak leaf patterns on doors, original furniture and fireplaces in New Park Manor commemorate the oak tree in which he hid from Cromwell's men, and his royal coat of arms is displayed prominently above the fireplace in the oak-panelled restaurant.

St Nicolas' Church is developed from a Saxon church. Adjoining the church is the Great Yew Tree. Its girth, which was 15 feet in 1793 and over 18 feet in 1930, is now more than 7 metres. The yew was carbon dated in the mid-1980s and a certificate stating that it is over 1,000 years old is on the wall by the font.

Lyndhurst

St Saviour's Church is a fine example of late Victorian Gothic. It was the original intention of Lieut Commander and Mrs E. L. Walker-Munro to build a private chapel for their residence, Rhinefield House. It was completed in 1890, just 2 miles from Brockenhurst, and is now a hotel. The then vicar persuaded the Walker-Munros that a new and larger church would be of value to the village and the present site was chosen.

Lyndhurst became important as 'the capital of the Forest' when William the Conqueror established his hunting grounds in the area nearly 950 years ago. It is Linhest or 'wood of lime trees' in the Domesday Book of 1086, though they are not found today. Today the prestigious Lime Wood Hotel is near Lyndhurst. In 1270 King Henry III granted Eleanor of Castile, his son Edward's wife, the Manor of Lyndhurst and stewardship of the forest. When they became King and Queen the forest was one of the first places they visited. Subsequent Queens held the Manor of Lyndhurst until 1354. Lyndhurst's manor house is known as Queen's House (King's House if there is a male monarch).

The current building dates from the time of Charles I. Lyndhurst is home to Verderers' Hall, the meeting place of the Verderers' Court whose history stretches back to at least the thirteenth century and employs the Agisters who check on the condition of the Commoners' stock.

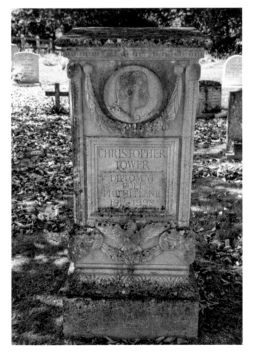

Above: St Nicholas, Brockenhurst, is built on a mound that may have been the site of a Romano-British church.

Left: Sir Christopher Tower (1915–98) gives his name to the library at the New Forest Heritage Centre, Lyndhurst.

DID YOU KNOW?

Daniel Defoe suggested, in a *Tour Through the Whole Island of Great Britain* (1726), that 10,000 refugees from the Rhenish Palatine who had fled to London in 1709 should be given land to settle between Romsey and Lyndhurst.

St Michael and All Angels Church has an impressive fresco of The Ten Wise and Foolish Virgins by Lord Frederick Leighton who became President of the Royal Academy. Prime Minister William Gladstone (1809–98) and his wife holidayed in Lyndhurst. Lloyds bank in the High Street has an old beehive sign instead of the current black horse.

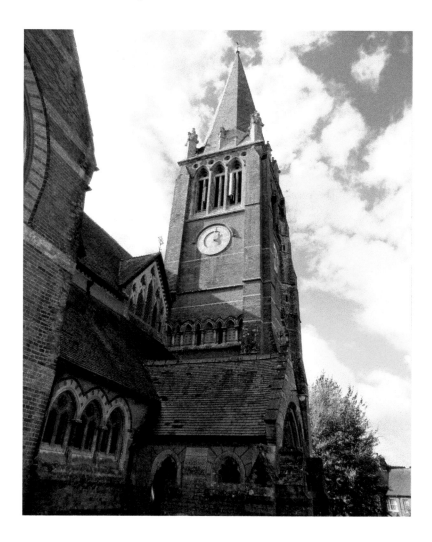

St Michael and All Angels has a 49-metre spire.

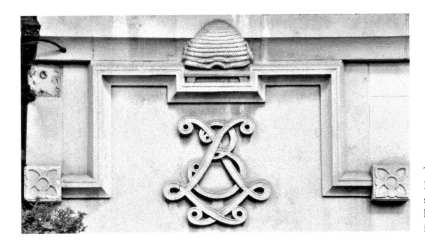

The Lloyds Bank beehive sign symbolised hard work and industry.

The Crown Stirrup pub is named after an ancient object that was used to decide who was allowed to take their dogs hunting in the New Forest in the eleventh century. As the story goes, if your dog fitted through the stirrup it was allowed. However, if it didn't, it was considered dangerous as it could savage deer and the dog's claws were cut off each fore paw. The stirrup still hangs in the Court of Verderers, at the seventeenth-century Queen's House. It measures 10.5 × 7.5 inches.

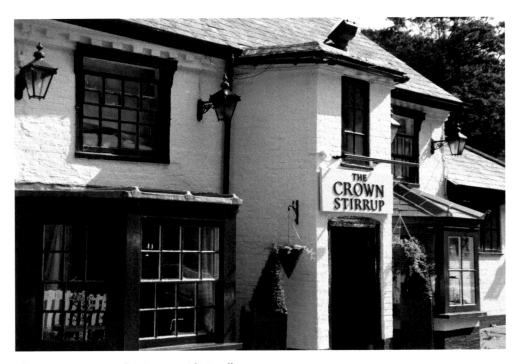

The Crown Stirrup pub is just outside Lyndhurst.

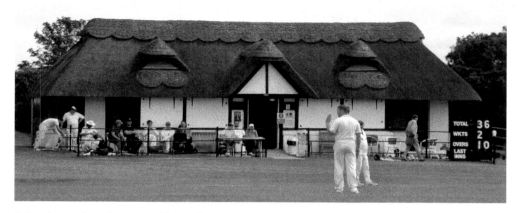

Bolton's Bench cricket ground has a thatched mock-Tudor pavilion.

The hill called Bolton's Bench is named after the Dukes of Bolton, once Lord Wardens of the Forest. The hill is linked to the legend of the Bisterne dragon.

DID YOU KNOW?

The sixty-eight-name First World War memorial was mainly designed and financed by local resident Alice Hargreaves, the inspiration for *Alice in Wonderland*.

Captain Sir Arthur Phillip RN (1738–1814) was the first Governor of New South Wales. He sailed from the Solent in 1787 to set up an agricultural colony for convicts at Botany Bay. Phillip landed on 26 January 1788, which is celebrated as Australia Day. He had farmed at Glasshayes in the 1760s. It later became the Grand Hotel, then from 1970 the Lyndhurst Park Hotel. He planted the first grapevines in Australia with plants taken from Cape Town. A commemorative plaque to Phillip is on sandstone brought from Sydney Cove in the 1980s. It is situated by the chapel at Lyndhurst cemetery.

Glasshayes was lived in during the 1860s by Charles Castleman.

DID YOU KNOW?

Admiral Sir Charles Burrard (1793–1870) lived at Holmfield and painted many watercolours of the area including the Butts rifle range.

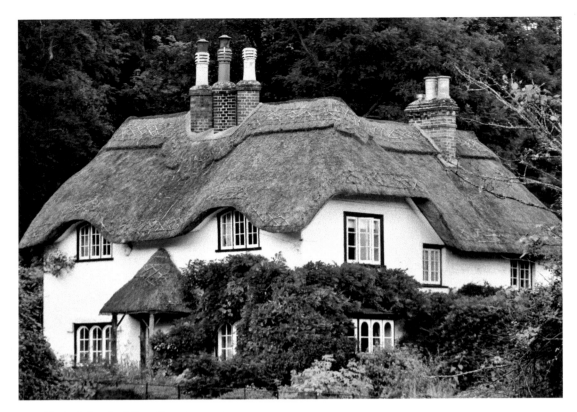

Typical thatched New Forest property.

DID YOU KNOW?

Sir Dudley's Ride is named after Sir Dudley Forwood (1912–2001), who moved to the Forest in later life. The Baronet was the sole equerry to the Duke of Windsor after his abdication.

Foxlease is an activity and conference centre set in 65 acres around the Princess Mary manor house which dates from 1792. The estate has been owned by the Guides since 1922. Henry Weyland Powell (1787–1840) was a High Sheriff of Hampshire in 1834, living at Foxlease. He was an ancestor of Robert Baden Powell, founder of the scouting movement.

Allum Green Cottage, Lyndhurst, was bought by novelist Vera Brittain in 1939. Bombing on the night of 5 September 1940 resulted in the deaths of four soldiers of the Royal Army Ordnance Corps. This is commemorated by a nearby bench erected in 1980.

Ringwood and Picket Post

Ringwood has had a Wednesday market since 1226, granted by Henry III. An ornate lamp was erected in Market Place in 1887 for Queen Victoria's Jubilee. In the nineteenth century Ringwood was noted for its wool glove making. The Georgian Meeting House, now a museum, built in 1727 as a Nonconformist chapel, the Town Hall and the Old Town Bridge are worth a visit.

An earlier building at Monmouth House is where the Duke of Monmouth was confined following an uprising. He was discovered hiding in a nearby ditch and beheaded in July 1685 at Tower Hill, London.

In his 1923 *A Guide to the New Forest*, Heywood Sumner wrote of Picket Post that 'This place is now usually spelt "Picket", but "picked" was the spelling in the Ordnance Map of 1817, and in all maps previous to that date Picked is a Wessex word in present use, meaning pointed. The name probably referred to the pointed angle of the roads that join here.'

Up until 1969 there was a tea house here whose distinctive sign was a large golden kettle. Today there are services on both sides of the road.

DID YOU KNOW?

Liberty's Owl, Raptor and Reptile Centre at Ringwood is home to the largest collection of owls in Europe.

DID YOU KNOW?

Ringwood Brewery has guided tours and one of its beers is called Snakecatcher after Brusher Mills, a New Forest resident and hermit who made his living catching snakes.

Peterson's Tower, Sway

Peterson's Tower near Sway is an early example of concrete made from Portland cement being used as a building material. The tallest structure in the world to be built this way, it is 66 metres high and has 330 steps. A 15-metre prototype is nearby.

Andrew Peterson (1813–1906) had been a High Court judge in Calcutta. Here he saw a prolific use of concrete as a building material as there was a local supply of cement. He retired to Sway in 1868. He wanted to provide work for forty unemployed locals.

Peterson was inspired by leader of the New Forest Shakers Mary Ann Girling to get into mesmerism and spiritualism. During a seance the spirit of Sir Christopher Wren, the architect of St Paul's, gave him the plans of the tower near Sway, known as Peterson's

Tower. It was originally designed as his mausoleum, with a perpetual light at the top. However, this was not allowed by Trinity House, as the light may have confused shipping. He lies next to his wife in St Luke's churchyard.

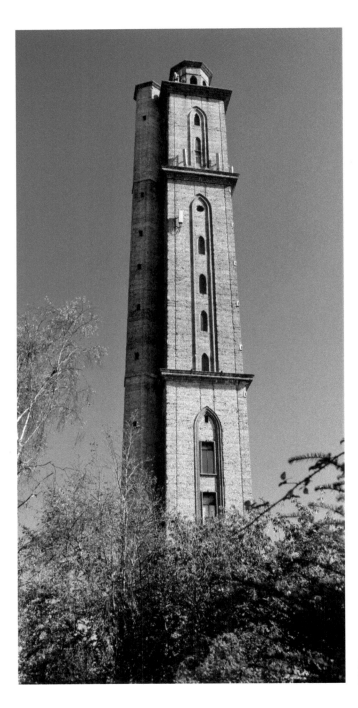

Sway Tower was built between 1869 and 1875.

5. Some New Forest Villages

The Forest is noted for its many picturesque hamlets and villages. Some have rather odd names, such as Sandy Balls, Burnt Balls, Anthony's Bee Bottom, Canada, Bohemia, Gang Warily, Lepe, Little Stubby, Nomansland and Normandy.

Ashurst

Following the completion of the London to Southampton railway in 1840 there was pressure to open up a line westwards to Dorchester. Lyndhurst Road station, although several miles away, was the nearest allowed to Lyndhurst by local landowners. This meant that Ashurst grew as a railway village from 1847. Today the station is called Ashurst New Forest. Today's A35 road through Ashurst was built on an old turnpike road.

In the 1930s, Forest House was converted into a guest house called the Angry Cheese. In the 1950s the son of the then owner of the Angry Cheese bought the Monkey Tree Hotel opposite. It was once a temperance hotel and he renamed it the Happy Cheese. The Angry Cheese shut in the 1960s and houses are now on the site. The Happy Cheese was destroyed by fire in 1976 but eventually rebuilt and is today a restaurant-pub.

Ashurst Hospital was once the New Forest Union Workhouse. Built in 1836, it once housed 200 including children. It was used until recently as an NHS hospital.

Bank

At Bank a telephone box by the Oak Inn serves as a tourist information point.

The Oak Inn at Bank.

Old telephone box repurposed.

Bartley

Bartley has a green tin village hall that was originally built as a place of worship. When local estate owner John Howard died in 1902 a tower and clock were added in his memory. The 'Tin Church' was sold for £10,000 and became a community facility in 1998. Milvina Dean (1912–2009), the youngest and last *Titanic* survivor, attended its opening ceremony. Milvina was just nine weeks old when the *Titanic* sank in April 1912. Her father died but Milvina was rescued along with her mother and brother. The last *Titanic* survivor lived in the area for many years, latterly at Woodlands Ridge Nursing Home.

Principles of Geology by Charles Lyell was published in the early 1830s. He spent his childhood at Bartley Lodge.

The bumpy Bartley cricket ground was first mentioned in 1869.

Bashley

At Bashley the Daneswood Stream and Daneswood area recall a battle between the Danes and Saxons.

The Bashley Wessex League football team has a Forest stag as their logo.

Beaulieu

The Cistercian Abbey at Beaulieu was founded by King John in 1204. Legend says that a bad dream of the Last Judgement led to John's generous gift. The name first appears in 1205, recorded as *Bella Locus Regis* or 'the beautiful place of kings'.

The Beaulieu River rises just north of Lyndhurst and is tidal in its lower section. The river is privately owned by Lord Montagu.

The famous Motor Museum was founded in 1952 in memory of John Montagu who persuaded parliament to abolish a 12-mph speed limit. It attracts more visitors than any other forest location with over 250 cars on display including vehicles from the James Bond films and the TV show *Top Gear*. It has James Bond's Aston Martin, complete with rotating machine-gun headlamps, that was used in a car chase scene in *No Time to Die*. Lord Montague said, 'Let's face it, after the characters, the cars are the most important characters in the film.' The museum's mile-long monorail was built in 1974.

DID YOU KNOW?

Beaulieu is twinned with Hautvillers in France where Dom Perignon developed the art of making champagne.

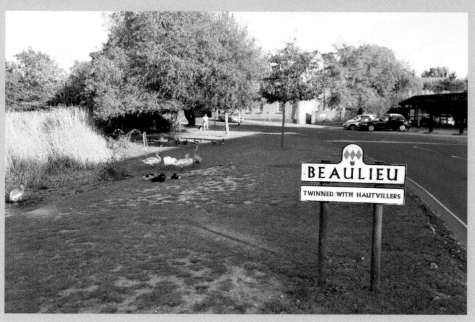

Left: Beaulieu estate land is marked by posts with three red lozenges (diamonds).

Below: Beautiful Beaulieu.

DID YOU KNOW?

The 1966 historical film *A Man for All Seasons* used the Beaulieu River to replicate the Thames.

The Royal Oak pub at Hilltop Beaulieu dates from 1848 and was originally a tearoom. The name recalls the Boscobel Oak where Charles II hid following the Battle of Worcester in 1651. Following the Restoration of the Monarchy, 29 May became Royal Oak Day as it was the king's birthday.

Perkin Warbeck was a pretender to the throne of Henry VII who persuaded some that he was Richard, Duke of York, the younger of the two 'Princes in the Tower' and an heir to the throne. Warbeck fled to Beaulieu for sanctuary in 1497 but was apprehended. He was allowed to stay at court so he could be watched. After a second attempt to escape he was hanged in 1499.

By 1916, the word 'BEAULIEU' was carved into the heath at East Boldre, in letters approximately 4.5 metres (15 feet) high, making the whole word spread over 33.5 metres (110 feet). The letters are quite unique. No other RFC or RAF training school had or has similar letters. The letters were covered up during the Second World War and do not appear on any aerial photographs of the day. In 2012, local villagers carefully uncovered the letters. The entire restoration process was televised on the 2012 BBC1 programme *A Great British Story*.

Ferny Crofts Scout Activity Centre is a 31-acre outdoor camping and activity centre near Beaulieu, established in 1976. It is owned and managed by Hampshire Scouts and is primarily open to scouts, guides, youth groups and schools. The oldest building on the site, known as The Croft, was named the Sky High Conservatory in recognition of the Hampshire Scouts who reached the summit of Mount Everest in 2007. In 2014 Chief Scout Bear Grylls visited Ferny Crofts as part of his Bear in the Air national tour.

DID YOU KNOW?

Opposite Beaulieu Road railway station there are horse sales several times a year with prices in guineas.

DID YOU KNOW?

St Leonard's Barn was built in the fourteenth century. The 25-metre-high barn was once the largest in England. Its size reflected the wealth of nearby Beaulieu Abbey until its dissolution in 1538.

Bisterne

Dragon Lane, Bisterne, is a reminder of the legend of the Bisterne dragon – a dragon that was said to appear daily from its Burley Beacon lair. The dragon was 'doing much mischief upon men and cattle' and demanding 'a pail of milk a day'. It was said to have been vanquished by Sir Maurice Berkeley of Bisterne who, accompanied by two mastiffs, Grim and Holdfast, destroyed the creature.

A carved dragon over a doorway at Bisterne Park House and effigies of the two dogs recalls the myth. It is said that the hill known as Bolton's Bench, Lyndhurst, is where Berkeley later died alone, exhausted by the battle. His yew wood bow fell to the ground beside him becoming the yew tree we see today. A deed of Edward IV (1442–83) exists which 'conferred knighthood upon, and granted permission to, Sir Macdonie de Berkeley to wear the dragon on his badge, for having killed a dragon at Bisterne, in the county of Southampton'. Today, Bisterne has a scarecrow festival in August.

Boldre

Arthur Mee, writing about Boldre in the 1930s, said that 'The village is here, there and everywhere.' The area known as East Boldre was previously known as Beaulieu Rails as it had grown up as a squatter settlement on common land by an earth bank marking the western boundary of the Beaulieu lands.

The Revd William Gilpin (1724–1804) became Vicar of Bolde in 1777 until his death. In 1791, he wrote of 'the groaning-tree of Badesly'. Around 1750 a villager frequently heard a sound like a 'person in extreme agony' behind his house, the noise coming from an elm tree. The fame of the tree was such that people came from far and wide, including Frederick, Prince of Wales, and Princess Augusta. Eventually the tree was uprooted but nothing unusual was found.

Gilpin achieved success as a writer, artist, clergyman and schoolmaster. In 1791 he published *Remarks on Forest Scenery, and Other Woodland Views*. He supported a project for a new poor house and provided an endowment for a parish school that now bears his name. He has a monument in the old Church of St John the Baptist, which is over 900 years old, and is buried in the churchyard. One of Gilpin's travel books is mentioned in Jane Austen's *Sense and Sensibility* published in 1811.

Poet Laureate Robert Southey (1774–1843) married his second wife at Boldre in 1839. She had been taught by William Gilpin.

Southey wrote the original version of *Goldilocks and the Three Bears*. He also introduced the word zombie derived from the Haitian French 'zombi'.

St John's contains the only memorial to the battlecruiser HMS *Hood* sunk by the *Bismarck* off Iceland in May 1942. Only three of the 1,418 crew survived. Vice Admiral Holland, its captain, was a member of the congregation and is buried there.

David Balme led a boarding party onto German U-boat *U110* in May 1941, which resulted in the seizure of game-changing intelligence material used by the Bletchley Park code-breaking centre. The plaque reads, 'In loving memory of David Edward Balme. Lieutenant-Commander DSC, RN 1st October 1920 – 3rd January 2016. Boarded German submarine 9 May 1941 recovered cipher material and Enigma machine.'

Boldre village green is called Perkins' Piece. In 1951 the former wheelwright premises had been bought by John Perkins, then chairman of the *Southampton Daily Echo*. He was refused planning permission to build on it, so in 1977 he gave it to Boldre Parish.

'The Queen of the Gypsies' Hannah Lakey died in 1903 at eighty-four years of age and is buried in Boldre.

DID YOU KNOW?

Tradition says that the pub in Boldre, the Red Lion, is named after a creature of local folklore, the Stratford Lyon. Supposedly a giant red lion with a wild mane, yellow eyes, large teeth, and huge stag-like antlers was found by John Stratford in a wood in South Baddesley around 1400.

Breamore

The flint Saxon church of St Mary's at Breamore has a lack of windows, thought to keep the Devil at bay.

Breamore House, in the shape of an E, dates from 1583 and was built for William Doddington, the Treasurer for Queen Elizabeth I. It was used as a filming location for Jane Austen's *Pride and Prejudice*.

In Breamore Woods there is a 26-metre-diameter mizmaze, possibly of Saxon origin, cut into the chalk. It is one of England's eight surviving historic turf mazes.

Grim's Ditch was built in late Roman times as a defence against the Saxons. Locals pronounce their village as 'Bremmer'.

DID YOU KNOW?

The Forest has around 250 round barrows or ancient burial chambers dating back to the seventh century.

Bramshaw and Brook

Bramshaw had an Admiralty telegraph site. Devised by Lord George Murray, the stations operated from 1806 and were used during the Napoleonic Wars.

A system of six large optical shutter boards representing a coded message were hoisted into the air. The next site would hoist the same boards. A message could go from the Admiralty in London to Plymouth in half an hour on a clear day. In the event of poor visibility, messages were carried by a rider on horseback.

The village had an iron foundry from 1794 and it made safes for local churches including Salisbury Cathedral.

The Green Dragon pub may be named after the Bisterne dragon legend.

Bramshaw Golf Club has two eighteen-hole courses. One from 1865 is the oldest in Hampshire. The hamlet of Brook also has a second pub, the Grade II listed Bell Inn, which is now run by the company who own the adjacent Bramshaw golf course, which dates from 1865.

Burley

Burley is a village of two parts: Burley and Burley Street. It has an Iron Age hill fort on Castle Hill. Witchcraft plays a role in the village's history. The New Forest coven met during the early twentieth century. A British occultist, Gerald Gardner (1884–1964), known as the 'Father of Wicca', described some of his experiences with the coven in his books *Witchcraft Today* (1954) and *The Meaning of Witchcraft* (1959). During the 1950s 'white witch' Sybil Leek lived in Burley and walked around in her long black cloak with her pet jackdaw sitting on her shoulder. One of the shops in Burley (A Coven of Witches) was named by her. With some upset by her presence, Sybil moved to America where she continued writing about the occult and astrology.

Constance Applebee lived to be 108. On her 100th in 1973 she received telegrams from both the Queen and the President of the USA as she had pioneered women's hockey in America. Burley has its own cider factory making unpasteurised, real cider.

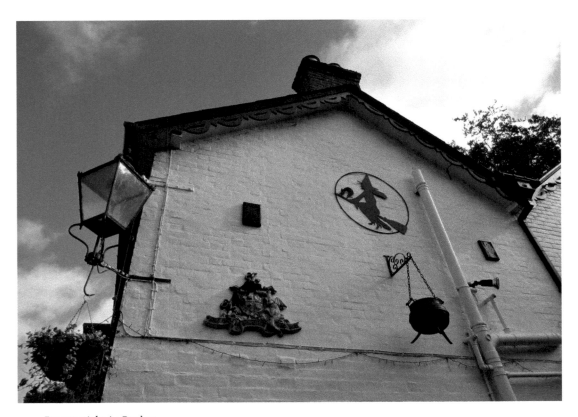

Broomsticks in Burley.

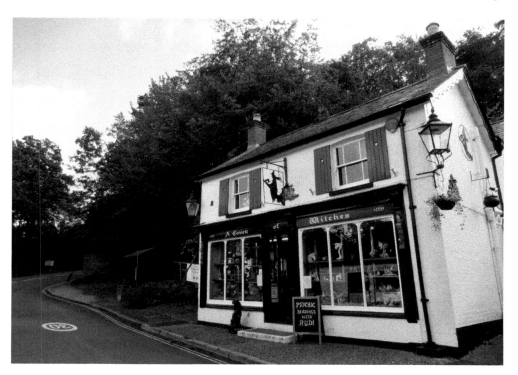

Coven of Witches shop.

The Queen's Head, Burley.

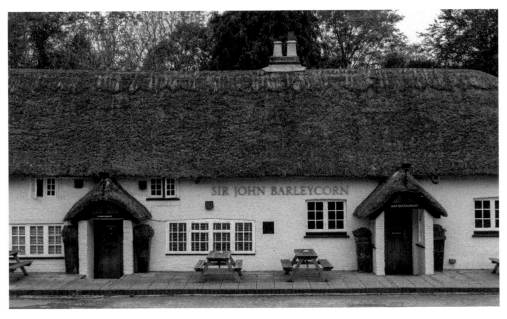

Robert Burns reworked seventeenth-century sources for his poem 'John Barleycorn'.

Cadnam

The name Cadnam derives from 'the homestead of a man called Cada' in Saxon times. It was listed in 1272 as Cadenham.

The White Hart pub is a heraldic reference to Richard II who inherited the area. The thatched Sir John Barleycorn pub refers to the old folk song that tells the story of barley and the dangers of drinking alcohol.

The Shave Green Inclosure has a mile-long Douglas fir-lined avenue dating from around 1860.

Canada

The village is on the edge of the parish of Wellow. It is a 'remoteness' name, possibly acquired in the middle of the 1700s when the country of Canada was a faraway place that was being talked about.

Colbury

Christ Church, Colbury, was built in 1870 in the Gothic Revival style. It has a tombstone for Charles Shave who was killed by a train at a level crossing on Christmas Eve 1878.

The Colbury Memorial Hall was built in 1928 by local landowner and resident Marianne Vaudrey Barker-Mill who had lost her son Claude in the First World War.

Denny Lodge

Denny Lodge is the largest parish in Hampshire at 25.6 square miles yet has no church or school. It does however have a railway station at Beaulieu Road by the Drift Inn.

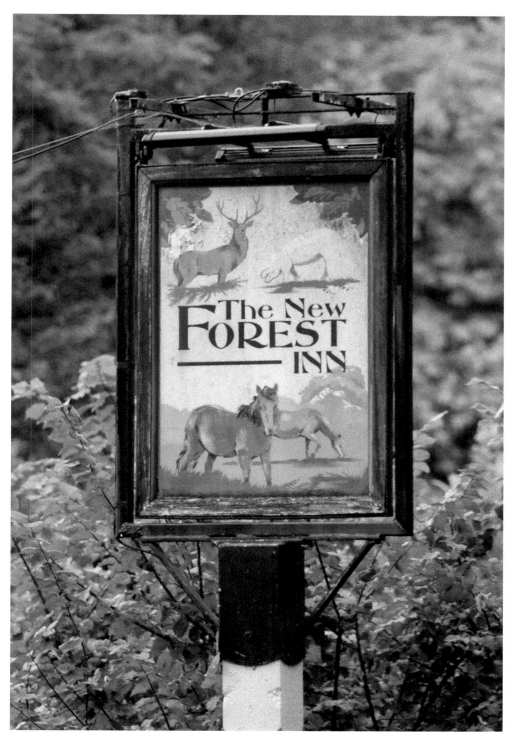

A dog-friendly pub at Emery Down.

MINSTEAD 2 1/2
STONEY CROSS 2 3/4
LYNDHURST 1
SWAN GREEN 1/4

Fingerpost signs are still in use around the Forest.

The nearby 4-mile-long Bishop's Dyke contains around 400 acres. It was granted in 1284 by Edward I to the Bishop of Winchester and remained church property until 1942.

Exbury

Exbury is named after the Exe, a former name of the Beaulieu River.

The lectern at St Katherine's Church is made from one of the propellers of HMAS *Sydney*. It was sunk in 1941 with the loss of all 645 crew. It was stolen in 1994 but retrieved in 1997 from a Hells Angels house in Southampton. Several members of the Mitford family are buried in the churchyard. They owned the estate in the eighteenth century.

The Rothschild banking family have owned Exbury House and Gardens since 1919. Their name means 'red shield'. The gardens are renowned for their rhododendrons, camellias, magnolias and azaleas, all at their best in spring. They cultivate the iridescent narine plants that originated from Table Mountain in Cape Town.

A large Burmese temple bell hangs from an oak tree and was struck to let Lionel de Rothchild know his dinner was ready. It is thought it was brought back around 1820 by Captain Marryat who later turned author.

The narrow-gauge steam railway departs from a replica Victorian station based on Aviemore in Scotland and is now over twenty years old. All the Exbury village cottages were built for estate workers.

Exbury House played an important role in the strategic planning of D-Day, designated as HMS *Mastodon* from May 1942. She was responsible for the administration of victualing, arming and training of crews for the landing craft.

King George VI visited Exbury on Wednesday 24 May 1944. Exbury has been used as a filming location for the Famous 5 and the original Worzel Gummidge series.

Fritham

DID YOU KNOW?

The hamlet of Fritham lost five men in the *Titanic* disaster of 1912. Its seventeenth-century Royal Oak pub, once a meeting place for smugglers, was awarded the Country Pub of the Year in the 2021 Good Pub Guide.

Eyeworth Pond, near Fritham, was originally created in 1871 as a reservoir for the nearby Schultze factory which made smokeless gunpowder. By 1895, it was the world's largest supplier of sporting gunpowder and the biggest employer in the Forest. Edward Schultze's factory once supplied 75 per cent of the world's gunpowder.

The gunpowder factory employed around 100 people in sixty buildings at the height of production but closed in 1921. The remote location was selected to limit potential damage should explosions occur. Today a small population of the Mandarin duck is resident on Eyeworth Pond.

The 1946 Irving Berlin musical *Annie Get Your Gun* was about sharpshooter Annie Oakley (1860–1926) who only used Schultze gunpowder.

Gordleton

Gordleton has an impressive seventeenth-century watermill on the River Avon and the restaurant serves local food. It has a 'Secret Garden' featuring the renovated Victorian pond and its Art Gardens are where local and national artists exhibit their work.

Minstead

Malwood Castle is thought to have been the most important Iron/Bronze Age fort in the Forest. A large country house was built there by Sir William Harcourt in 1885 and is Grade II listed. He was a Privy Councillor to Queen Victoria. Legend says that King Rufus slept at the castle in an earlier lodge the night before he died at Canterton.

Charcoal burning was once a major local industry based around Minstead. It was a charcoal burner, Purkis, who found the body of William Rufus and transported it on his cart to Winchester via Romsey. The tradition died out in the early twentieth century but has been revived today using quicker modern methods by the Pondhead Conservation Trust.

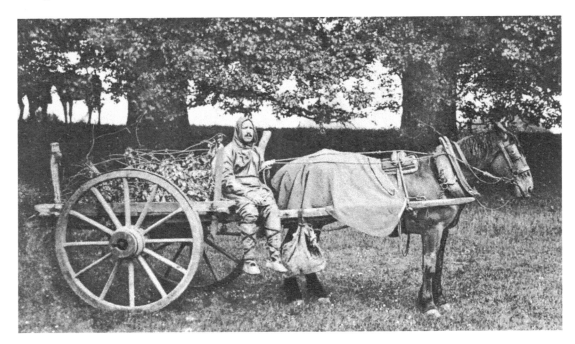

Charcoal burner in 1907.

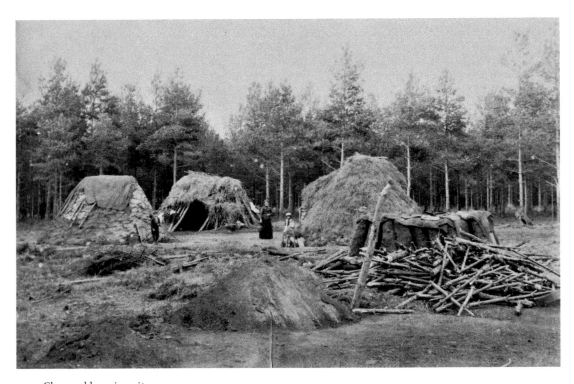

Charcoal burning site.

An eighteenth-century engraving.

Marchwood

The name 'Marchwood' is most probably from the Old English *merece wudu*, meaning 'smallage wood'. Smallage is a term for wild celery.

Closed since 1966, Marchwood railway station still exists in reasonable condition. The Waterside Transport Strategy has plans to reopen the train route. The scheme will see three stations opened on the route with two current stations at Hythe and Marchwood reopening and a new station built at Hardley.

Cracknore was the landing place of the ferry from Southampton before the Hythe Ferry. Marchwood Military Port was built here during the Second World War, which played a vital role in the Normandy landings. The Royal Navy Ordnance Depot was where the famous Mulberry Harbours were made. The ammunition facility is remembered in the name Magazine Lane. The village is home to the 17th Port and Maritime Regiment, part of the Royal Logistics Corps.

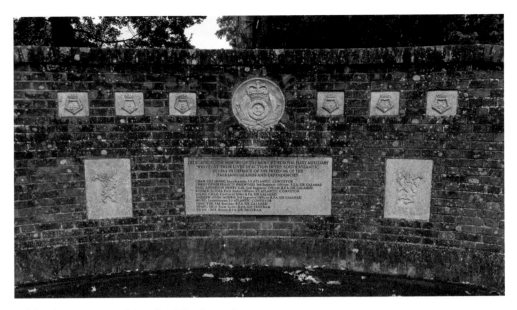

Falklands War memorial wall at Marchwood.

Grade II-listed Marchwood Priory is now part of the private Priory Hospitals chain and has treated celebrities such as footballer Paul Gascoigne. During the war, it was a centre for treating badly burnt pilots on the programme devised by the surgeon Sir Archibald McIndoe. Outside the Church of St John the Apostle is a Falklands Memorial. It commemorates the lives of the Royal Fleet Auxiliary personnel lost on RFA *Sir Galahad*, which sank, and the RFA *Sir Tristram*, which was badly damaged during the 1982 campaign.

Opened in 2014, Staplewood Football Development Centre in Long Lane is the training ground of Southampton FC.

DID YOU KNOW?

Marchwood has a Fijian military community.

DID YOU KNOW?

Near Wilvery Enclosure the Naked Man is the name given to the remains of an old oak tree. It was once used to hang highwaymen and smugglers until the weather and the birds picked the bones clean.

New Milton

The Manor of Milton is in the Domesday Book as 'Mildetune' and excavations have revealed dwellings here from the ninth century.

New Milton railway station opened in 1888.

Milton's octagonal Water Tower from 1900 holds 200,000 gallons and is reminiscent of a medieval castle. After a 1942 bombing raid, German radio incorrectly announced that it had bombed 'a fort in the New Forest'. It was camouflaged, which may have led to it being thought of military importance.

New Milton has several links to motorbike racing. Samuel Hamilton Miller MBE (b. 1933) was an eleven-time British Champion motorcycle racer and won over 1,400 events in a career spanning fifty years. The Sammy Miller Motorcycle Museum is at Bashley.

In 1960 Derek Rickman (1933–2021) and brother Don built the light-framed Metisse motorbike – French for a female mongrel.

In the mid-1960s movie star Steve McQueen was recommended to them by his stunt rider Bud Ekins, who did the famous bike wire leap in *The Great Escape*. McQueen bought a Metisse in battleship grey after testing the bike around the streets of New Milton.

DID YOU KNOW?

At one time in the 1970s, the Rickmans were the only motorcycle producer in England making over 16,000 units.

Netley

Netley Marsh was the site of a battle around 508 between victorious Anglo-Saxon invaders under Cerdic and Romano-Celtic peoples led by King Natanleod. He was killed, his name developing into the name of the area. Today Netley Marsh is noted for its popular Steam and Craft Show held in July.

Minstead

Minstead was listed in the Domesday Book as Mintestede as wild mint grew in the area. On the village green is a chestnut tree planted to mark the Silver Jubilee of King George V and Queen Mary in 1935. Replica village green stocks were made for the Queen's Golden Jubilee in 2002.

The Trusty Servant pub in Minstead has the composite animal emblem of Winchester College on its sign.

A Trusty Servant's Portrait would you see,
This Emblematic Figure well Survey.
The Porker's Snout not Nice in diet shows;
The Padlock Shut, no Secrets he'll disclose;

Patient the Ass, his Master's wrath will bear;
Swiftness in Errand, the Stagges feet declare;
Loaded his left Hand, apt to Labour saith;
The Vest his Neatness; Open hand his Faith;
Girt with his Sword, his Shield upon his Arm,
Himself and Master he'll protect from Harm.

The Compton family have been Lords of the Manor of Minstead since the 1500s. Minstead Manor, built in 1719, is still privately owned.

Minstead Lodge was once owned by Dr Duncan, a physician to Queen Victoria. The 6th Baron Congleton bought Minstead Lodge in 1924 and Lady Congleton was a very active member of the community. She was awarded an MBE in 1941 and was Minstead's first female churchwarden. Today Minstead Lodge is a venue for meetings, weddings and celebrations.

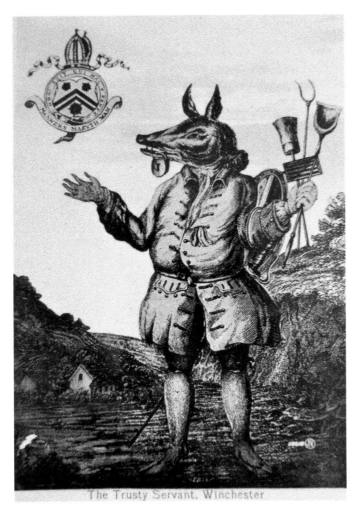

The Trusty Servant, Winchester

The multi-skilled Trusty Servant with his 'Manners Maketh Man' motto.

As part of Minstead Trust, it provides training in hospitality and catering for people with learning disabilities, who also tend the Victorian walled vegetable garden to provide seasonal vegetables for conference lunches.

Hanger Farm was first recorded in Saxon times and now has an arts centre run by the Minstead Trust Charity which helps those with learning disabilities.

Hanger was listed as a settlement in the Domesday Book. Over the centuries the spelling of Hanger has changed with the area also being known as Hangre, Hangere and Hangra, which in Old English means wooded slope. In 1901, farmworker William Phillips died when he was loading a cart at Hanger Farm. The horse bolted and he was run over by the cart. The subsequent theft of funds raised to support his widow Caroline and ten children shocked the local community. West Totton was built on much of the former farm.

DID YOU KNOW?

The thatched Fleur De Lys pub at Pilley claims to be the oldest in the Forest.

Nomansland

The village of Nomansland on the Hampshire/Wiltshire border dates from 1802. John Sillett (1936–2021), who was manager of Coventry City when they won the 1987 FA Cup, was born here. His father ran the Lamb Inn.

The Well of Sacrifice at Nomansland is an impressive war memorial above a spring.

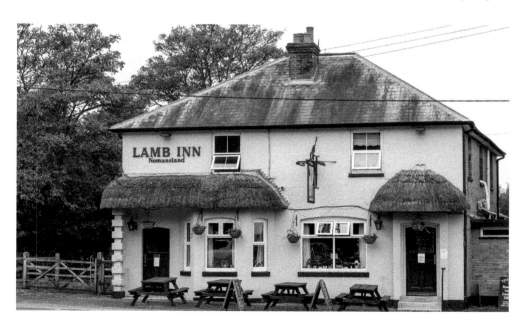

The Lamb Inn at Nomansland.

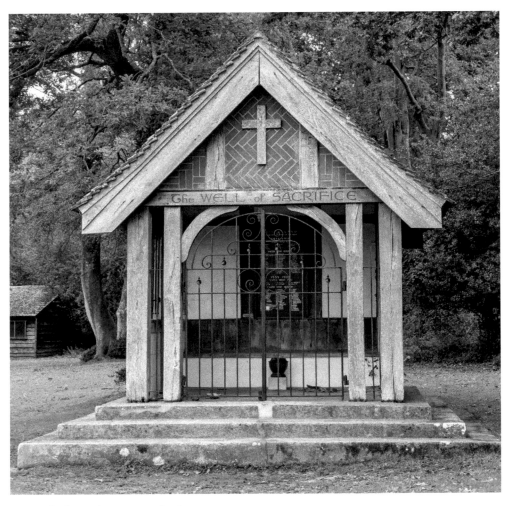

The Well of Sacrifice, Nomansland.

Ower
Paultons Park at Ower is a popular amusement park known for its Peppa Pig attraction. It has been owned by the Sloane Stanley family, owners of Sloane Square in London, since 1646.

Thorney Hill and Thorns Beech
Thorney Hill, between Burley and Bransgore, has for a long time been associated with gypsies. In 1926 gypsies and travellers were no longer allowed to camp out on the open forest. Thorney Hill was the largest of the seven compounds provided, with up to 400 inhabitants. During the 1930s mains water was brought in but with only one tap to serve many families. Around 1960 Hampshire County Council decided to take all the gypsies off the Forest and erected second-hand prefabricated houses on the compound site. Water

and electricity was provided and also a warden and a social worker to help the families settle. Tents and caravans were no longer allowed.

As new brick-built council houses were being erected, the pre-fabricated buildings were taken down to stop squatters moving in. By 1974 there were only four families left, the rest having been settled into council housing. All Saints Church, built in 1906 in a baroque style, was used by locals and gypsies. Unusually, it faces north-south. Inside is a mural containing some famous faces such as Poet Laureate Lord Tennyson who spent many years living at Freshwater on the Isle of Wight.

Thorns Beech residents have included Dire Straits members Mark Knopfler and John Illsley. In 1990 John bought his local pub, the East End Arms, to save it from closure. Some of his artwork is in the bedrooms.

Thorns Beech was once home to Britain's richest man, Sir Jim Ratcliffe, before his move to Monaco.

Totton

The town of Totton is between Southampton and the eastern Forest boundary. The original village was once reputed to be the largest in England. Today, Totton and Eling's population has grown to around 29,000 people.

Batts Corner is connected to musician Mike Batt, the creator of the Wombles. His grandparents had a general store there run by the female family members and the nearby Batt Brothers Motor Works was run by the men.

Testwood Lakes has one of the oldest known bridges in England, believed to date to around 1,500 BC. A Bronze Age dagger was found there.

Not a Womble in sight!

6. The North of the Forest

The major town is Fordingbridge and on its edge is an eighteenth-century milepost that says 'Fordingbridge 0'. It is twinned with Vimoutiers in France, near the cheese-making village of Camembert.

Many Fordingbridge houses were destroyed by fire in 1702. Some replacements can still be seen with the 1703 date on them.

An impressive seven-arched medieval bridge from 1362 crosses the Avon. Due to the threat of invasion in 1940, the Royal Engineers placed explosives into the medieval structure.

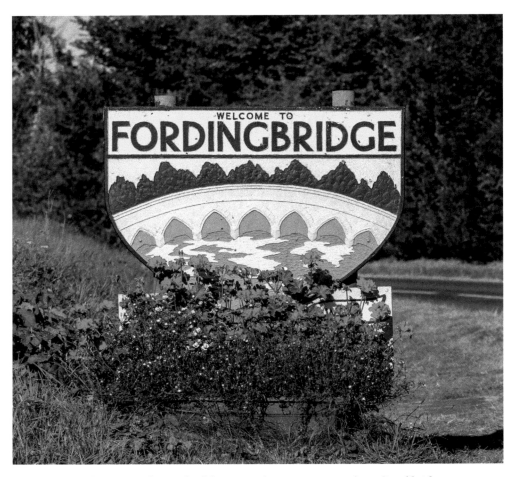

The Fordingbridge sign in the north of the Forest shows its seven-arch medieval bridge.

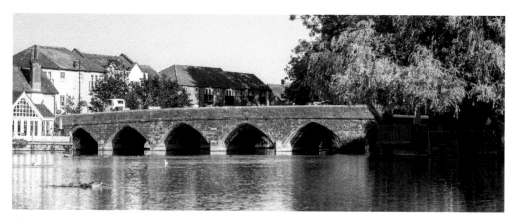

The medieval bridge at Fordingbridge.

Hollywood film star James Mason (1909–84) visited Fordingbridge in 1976 to open an animal welfare shop today called Animals' Voice.

DID YOU KNOW?

F1 racing commentator Murray Walker (1923–2021) lived at Sandleheath near Fordingbridge.

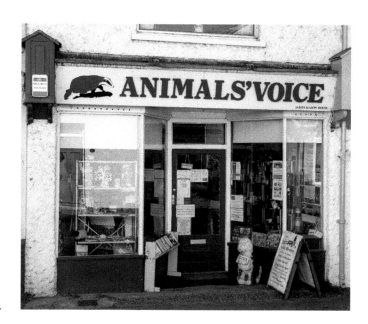

The James Mason House name can be seen on the right-hand side of the Animal's Voice sign. The actor and animal rights supporter bought the premises and visited in 1976.

Sandy Balls

Nearby Sandy Balls, its name coming from the large sandy hills that occur locally, was created in 1919 by landowner Ernest Westlake for members of the Order of Woodcraft Chivalry, a scouting-like movement with elements of paganism and some links to the Quakers.

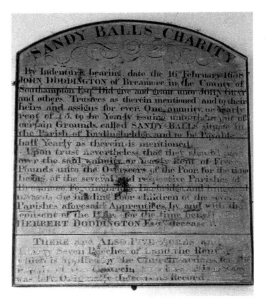

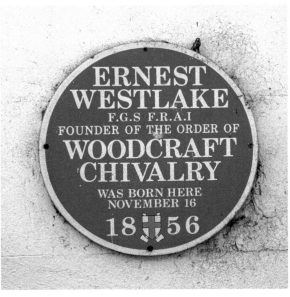

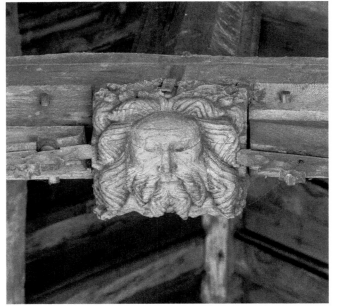

Above left: Sandy Balls Charity sign in St Mary's Church, Fordingbridge.

Above right: Plaque in Fordingbridge.

Left: A Green Man carving in St Mary's Church.

On May Day the choir of St Mary's Church sing madrigals from the tower.

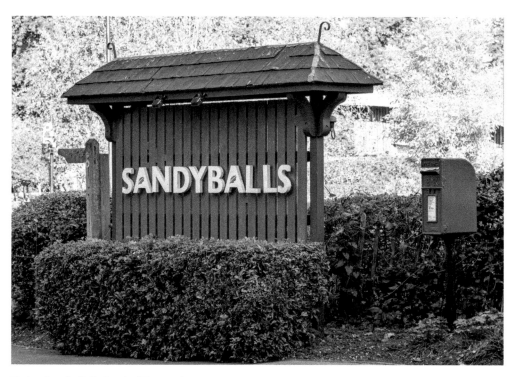

Today Sandy Balls is a holiday park.

Bickton

Bickton, a mile south of Fordingbridge, is the Hampshire village furthest from a railway station.

Hale

Hale is on the border of the New Forest, near Fordingbridge. In 1975 Hatchett Green was 'seized' by the parish council and villagers as there was no legal owner. Around 200 witnessed the ancient ceremony of a sod being cut, held up and then replaced. The village green was then registered at the Land Registry.

Godshill

Godshill had a 1930s Grith Fyrd camp founded by the Order of Woodcraft Chivalry. The name means 'peace camp' in Old English. The camp would have up to fifty people living a simple communal life, using a barter system.

There is a tenuous link to singer Marianne Faithful. Marianne partly grew up in the seventeenth-century Braziers Park, Oxfordshire, as did writer Ian Fleming. At one time Braziers also functioned as an Order of Woodcraft Chivalry commune of which her father was a member.

DID YOU KNOW?

Hampton Ridge has a large 30-metre-long arrow to show planes the direction of the Second World War Ashley Walk bombing range.

Rockbourne

There was a Roman settlement at Rockbourne. A forty-room villa was discovered in 1942 by a farmer digging out a ferret. Recognising the significance of the finds, the land was bought by A. T. Morley Hewitt who conducted excavations every summer from 1956 to 1978.

In 1967, 7,717 bronze coins were found buried in a pottery jar on the site. The hoard was buried around 295, and perhaps suggests that troubled times had affected the villa. Two damaged Roman milestones were found reused in the building's fabric.

7. The New Forest Coastline

When people think of the Forest, they imagine ponies in a wooded setting. In fact, there is a considerable length of coastline.

DID YOU KNOW?

Along with Woodbridge in Suffolk, Eling Tide Mill is one of only two remaining tide mills in Britain.

Eling Mill

Cobb was the King's Fletcher and the family held coblands in return for supplying the King with arrows when he came to hunt. It is said he made the arrow that killed William Rufus in 1100. The earliest surviving reference to Eling Tide Mill is in the Domesday Book in 1086.

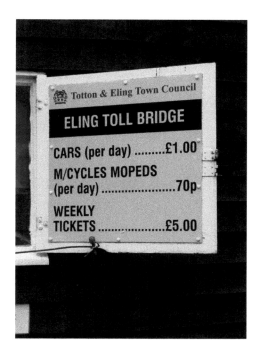

Eling Toll Bridge charges in 2021.

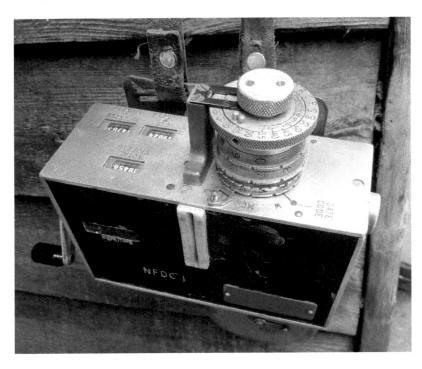

Left: Toll bridge ticket machine.

Below: Eling Tide Mill adjacent to the bridge.

In the 1200s, King John sold the manor and mill. In 1382 they were purchased by the Bishop of Winchester. He gave them to a school he was founding as a source of income. The school, the famous Winchester College, owned the mill from 1382 to 1975, and leased it out.

The invention of steam power plus cheaper imported grain resulted in steam-powered roller mills across the country to mill grain from Canada and elsewhere. Small mills using millstones (whether tidal, wind or river powered) found it difficult to compete. Eling struggled on by producing animal feed until 1946 when production ended. In 1975 the mill was bought by New Forest District Council who began to restore it as a site of industrial archaeological importance. With the surrounding riverside walks and adjacent heritage centre and cafe, it now forms the Eling Tide Mill Experience.

The tombstone for William Mansbridge in St Mary's Church graveyard reads:

Stop reader pray and read my fate,
What caused my life to terminate,
For thieves by night when in my bed,
Broak up my house and shot me dead.

Hythe

Hitheferye is named on Saxton's 1575 map of Hampshire. Today the 700-yard Grade II listed Hythe Pier is the seventh longest in the UK and was officially opened on 1 January 1881. It is believed to be the oldest continuously operating public pier train in the world.

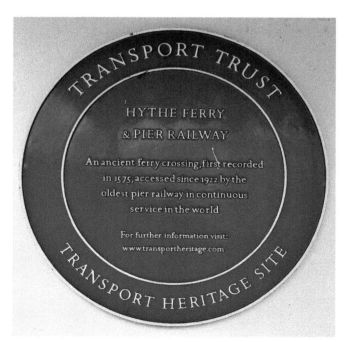

The world's oldest pier railway started in 1922.

A 2-foot-wide railway track was laid in 1909 for a hand-propelled luggage trolley. The present train arrived from a mustard gas factory at Avonmouth. Local historian Alan Titheridge explains how these engines came to be in Hampshire:

> Mr Thomas Percy who owned the ferry and the pier came into possession of a war office surplus materials catalogue at the end of the First World War. Listed there were the track units, lengths of rail and various other railway equipment – by 1922 they had this railway running up and down the pier.

The Hythe Pier train was 'such a funny old train', said King George VI on a visit just before D-Day in 1944. Hythe Pier Heritage Association now owns the pier and railway for the community. The *Empire Windrush* ship brought one of the first groups of Caribbean migrants to the UK. There is a Windrush Way in Hythe.

A famous resident of Hythe was hovercraft inventor Sir Christopher Cockerell (1910–99). In an effort to get his engineering-mad son more interested in the arts, Sir Christopher's father took him to visit several friends including Thomas Hardy, Hilaire Belloc and T. E. Lawrence (of Arabia). Christopher enjoyed that visit the most as Lawrence showed him his motorbikes. Lawrence later tested the RAF 200 series of rescue powerboats at the British Powerboat Company in Hythe from 1931/32.

He moved to Hythe in the early 1960s and lived in a waterfront property at Prospect Place next to the entrance to Hythe Marina. The dilapidated house had been unoccupied for over twenty years when it was bought from the Cockerell family in 2020. Sir Christopher began to develop the hovercraft in the 1950s, successfully testing the concept using two coffee tins and a hairdryer. The SR-N1 prototype made its first public appearance on the Isle of Wight in June 1959. A month later it crossed the English Channel. In 1960 Hovercraft Development Ltd was set up at Grove Garden, Hythe, where he was technical director until 1966.

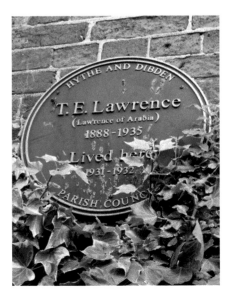

Lawrence of Arabia lived and worked in Hythe in the early 1930s.

A memorial by Robert Koening was unveiled at Hythe in 2000 by his daughter. The funding of the sculpture was by a developer who built new houses named Sir Christopher Court.

On 20 June 1940, All Saints Church at Dibden became the first in the country to be destroyed by enemy action following a raid on the Royal Naval Armaments Depot at Marchwood.

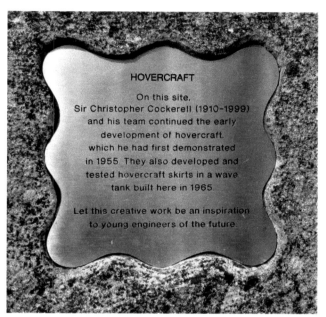
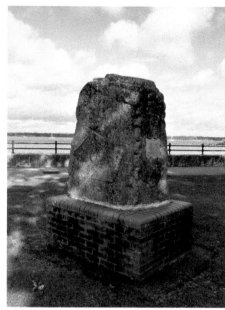

Above left: : Cockerell developed the hovercraft at Hythe on Southampton Water.

Above right: Hovercraft monument, Hythe.

Right: Sir Christopher Cockerell's former house.

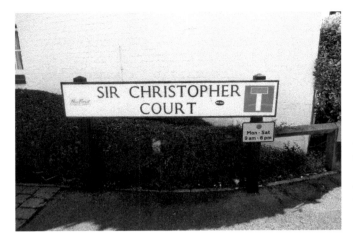

Left: Sir Christopher Cockerell once designed hovercraft.

Below: Dibden church, dating from 1262, was not re-consecrated until 1955 following bomb damage.

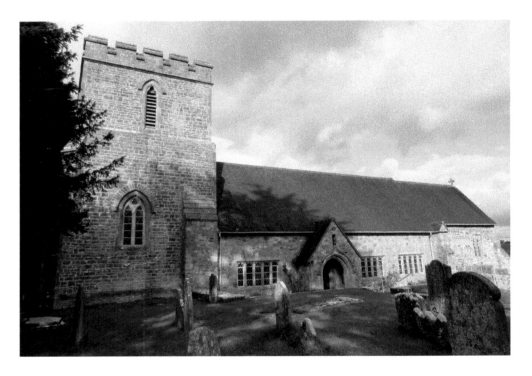

Langley

Marianne Vaudrey Barker-Mill owned the Grade II listed Langley House and her estates were managed from there.

A young Tommy Cooper (1921–84) lived in Langley and went to Fawley Junior and Hardley School before working at the British Powerboat Company, Hythe, in 1935. It was whilst wrongly performing a trick in the works canteen that he realised that he could get more laughs that way than doing tricks correctly.

Ashlett Creek

At Ashlett Creek the present mill dates from 1816 but there has been a mill there since 1241.

Many of the photographs of Edward Mudge (1881–1964) were made into postcards and are used in local books and websites. Born in Southampton, he moved in 1904 to a houseboat in Ashlett Creek where he had a darkroom in the mill attic for developing his photographs.

In 1936 he opened a shop and photographic studio in Fawley which operated until 1955. Mudge used a glass plate camera to the end of his life, even though camera technology had long moved on.

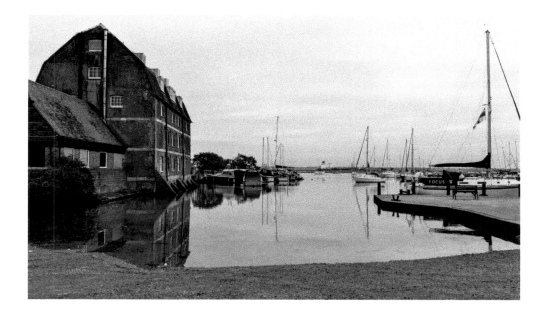

Above: The former mill at Ashlett Creek.

Right: The Jolly Sailor pub, Ashlett Creek.

DID YOU KNOW?

The twelfth-century All Saints Church at Fawley is the oldest building in the area and was bombed in 1940.

All Saints, Fawley, has Saxon church records dating back to 971.

Fawley

DID YOU KNOW?

Gang Warily Recreation Centre is named after the Drummond Clan motto which means 'Go Carefully'.

In 1921, the Atlantic Gulf and West Indies Company purchased land from the Cadland Estate for an oil refinery that was acquired by Esso in 1925. The wartime Pipe-Line Under the Ocean (PLUTO) took fuel from Fawley to the Isle of Wight then across to Cherbourg.

The current refinery, opened in 1951, is now the largest in the UK, covering 3,250 acres and producing 270,000 barrels a day in 2021.

The nearby power station's iconic round control room was used as a film location in *Rollerball* (1975), *Mission Impossible: Rogue Nation* (2015) and *Solo: A Star Wars Story*

(2018). It featured in TV shows such as the 'Harvest' episode of *Endeavour* and the 'Give and Take' episode in series eleven of *Red Dwarf*.

When John Betjeman addressed the Solent Protection Society before construction began on Fawley Power Station he spoke of the 'new architecture of power'. Fawley was the fifth of thirteen huge power stations commissioned by the Central Electricity Generating Board (CEGB) in the late 1960s.

The chimney is the subject of a children's book, *Top Gun of the Sky*, by Martin Bradley, about the peregrine falcons that used to nest on its apex. The 198-metre chimney was taller than the Post Office Tower in London. The early 1970s oil crisis meant the power station was never used to full capacity.

Demolished in 2021, housing is being built on the site.

Calshot

Calshot is the easternmost point of the Forest. Around a mile out to sea is a bank named the Brambles. When tides allow, an annual cricket match has been played for over forty years in the Solent. For a few hours the Island Sailing Club and the Royal Southern Yacht Club attempt to play on a sandy pitch that is usually rather moist!

Both Calshot and Hurst castles used stone from the ruined monastery at Beaulieu. They formed part of Henry VIII's chain of coastal defences to counter the threat of invasion by the Catholic powers of Europe. In 1913 Calshot became a seaplane base and one of the first Royal Naval air stations. From 1945 it was a coastguard station until it closed in 1961. Colonel T. E. Lawrence (of Arabia) was based at Calshot from 1929 to 1931.

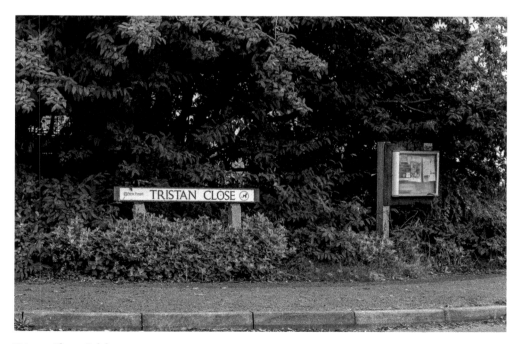

Tristan Close, Calshot.

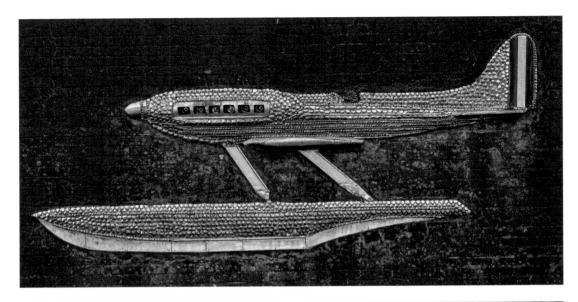

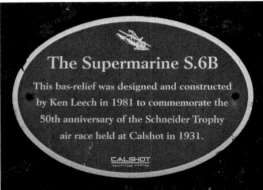

The Supermarine S.6B

This bas-relief was designed and constructed by Ken Leech in 1981 to commemorate the 50th anniversary of the Schneider Trophy air race held at Calshot in 1931.

CALSHOT

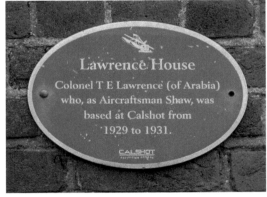

Lawrence House

Colonel T E Lawrence (of Arabia) who, as Aircraftsman Shaw, was based at Calshot from 1929 to 1931.

CALSHOT

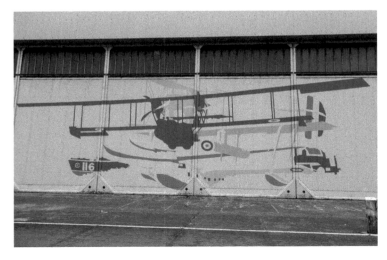

Top: The Flying Boat mural is made of shells.

Above left: A forerunner of the Spitfire.

Left: Calshot hangar mural, Calshot.

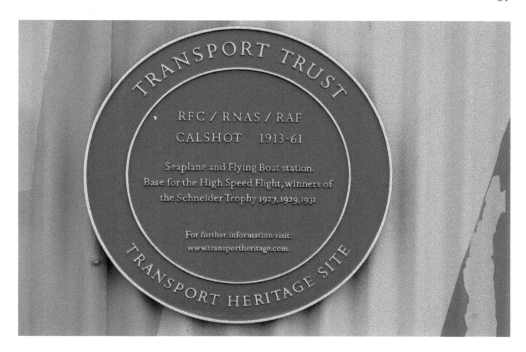

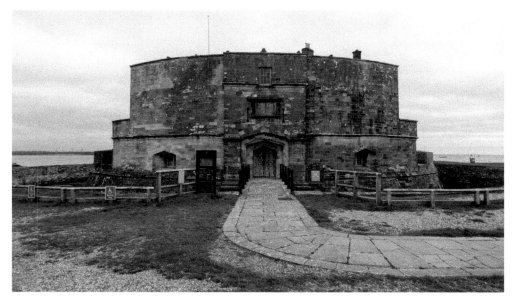

Calshot Castle was built in 1539–40 on a shingle spit, to guard the entrance to Southampton Water.

The British Overseas Territory of Tristan da Cunha dates from 1816. In the Atlantic between South Africa and South America it is the world's most remote inhabited island. It was named in 1506 after a Portuguese sea captain called Tristan da Cunha.

All 264 inhabitants of the volcanic island were evacuated after an eruption on 10 October 1961. A Dutch ship, the *Tjisadane*, took them to Cape Town. The islanders sailed to England on the *Stirling Castle*. They were housed at a former RAF camp at Calshot. Eventually, some 200 people returned to their island; a few stayed in the Southampton area. There is a Tristan Close in Calshot.

The Schneider Trophy air race winning speeds had risen from 107 mph immediately after the First World War to 280 mph by 1927. The race came to Calshot in 1929 and 1931, the last time it was held. The winner was a Supermarine S.6B flown by John Boothman, who notched up a speed of 340.08 mph. It was designed by R. J. Mitchell, who went on to lead the team that developed the Spitfire. Mitchell's rise to fame, including his involvement in the Schneider Trophy, was depicted in the 1942 movie *The First of the Few*, part of which was filmed at RAF Ibsley, north of Ringwood.

Lepe

Close to Calshot is Lepe. The name comes from the Old English 'help', which was a fenced grazing area that allowed animals to jump over. It is possible that Lepe provided a landing point for the Saxons. Once it was a departure point for the Isle of Wight. The Watch House dates from 1828 but is now a private residence. Near there navy ships were once built, the first being the fifty-gun Greenwich in 1748.

Around 6,000 military men left from Lepe on 6 June 1944. Tanks were loaded here and some of the special beach mats are still visible.

Lepe had a Royal Observer Corps bunker in the event of a nuclear attack.

The dog-friendly Lookout Cafe at Lepe is on stilts.

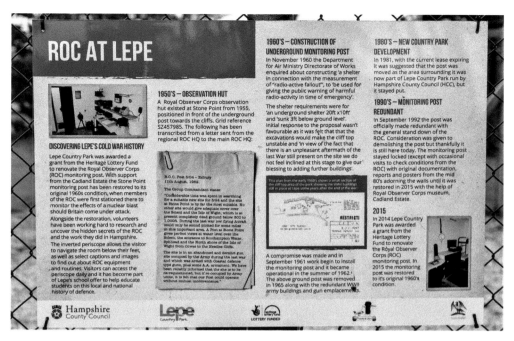

Royal Observer Corp underground monitoring post at Lepe.

Luttrell's Tower

Luttrell's Tower (aka Eaglehurst Tower) is currently a holiday let. The folly was built in 1780 by Temple Simon Luttrell MP. Queen Victoria considered buying it before she bought Osborne House on the Isle of Wight. Old maps show a nearby settlement, possibly connected to smuggling, called Lazytown.

Bucklers Hard

Bucklers Hard is a part of the Beaulieu Estate with a delightful river walk from Beaulieu. Around 1570 the Tudors created a Surveyor General of the Kings Woods to provide timber for naval ships. The demand for timber increased and parts of the Forest were inclosed (fenced) for this purpose. In 1698 William III passed an Act to create more inclosures for protected timber production, for use by the Navy. With the need for straight trees, an Act of Parliament of 1698 made it illegal to pollard trees. Commoners had previously cut back trees causing them to branch in several directions. They used the leaves and twigs for animal fodder, firewood and house frames.

Originally designed in the early 1700s to receive and refine sugar from the 2nd Duke of Montagu's estates in the West Indies, it developed into a shipbuilding village. In 1745 the first ship built at Bucklers Hard was the HMS *Surprize*, a twenty-four-gun sixth rate ship of the Royal Navy. In 1781 Nelson's favourite ship, the *Agamemnon*, was built here.

It is estimated that it took around 100 acres of woodland and 2,000 trees to build the 3,500-ton HMS *Victory*. Between 1745 and 1818 around seventy oak royal and merchant

navy ships were built here using New Forest timber. The wide verges on either side of the central path were for the stacking of timber. Some Arab dhows even used forest timbers for their masts.

Three Bucklers Hard-built ships were in Nelson's fleet at the Battle of Trafalgar in 1805. His favourite, the 46-gun HMS *Agamemnon*, costing £24,000, was launched from here in 1781. It was built by Henry Adams who lived in what today is called The Master Builder hotel and built *c.* 1729. Its most famous tenants were Henry and his sons, Master Builders of seventy ships for the Navy, including three which fought at Trafalgar – *Agamemnon*, *Swiftsure* and *Euryalus*.

In 1861 HMS *Warrior*, the first ironclad warship, was commissioned and soon wooden warships became obsolete. It was named *The Master Builder's House* by John, 2nd Lord Montagu of Beaulieu, in 1926 when it opened as a hotel. Queen Mary visited during the annual Cowes Regatta. In 1943 the Military Police took over the Master Builder Hotel whilst dummy landing craft were assembled in the field behind. They were then moored in the River alongside real landing craft to check how realistic they were. These dummy craft were later used to fool the Germans into thinking that any invasion of Northern Europe would be in the area around Calais.

Torpedo boats used in D-Day were also built here. The Chichester Room recalls Sir Francis Chichester, who in the 54-foot Gipsy Moth IV, became the first person to complete a solo circumnavigation of the earth in 1966–67. Bucklers Hard shopkeeper Mrs Rhoda Martin's task was to preserve eggs for the trip by covering the shells with liquid paraffin and de-eyeing hundreds of potatoes to prevent them from sprouting. Gipsy Moth is now in Guernsey. The Hon. Mary Montagu-Scott, commodore of the Beaulieu River Sailing Club, said she hoped 'the Guernsey Sailing Trust continue to use her to inspire a new generation of young people to take up sailing'.

Bucklers Hard shipbuilding village.

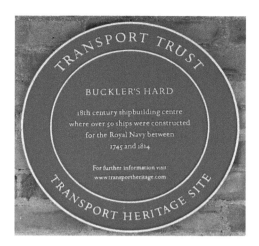

The Beaulieu River at Bucklers Hard.

Lymington

The River Lymington begins as a spring on Stoney Cross Plain. It then winds south-easterly for 25 km before entering the Solent at Lymington. RAF Lymington was used from 1943 to 1945. American Thunderbolts were based there. Today, it is the only place in the Forest where you can land a plane.

DID YOU KNOW?

The two-minute train journey from Lymington Pier to Lymington is only 666 metres.

Dating back to 1833, Lymington Sea Water Baths is the oldest open-air natural swimming pool in the UK. Mrs Beeston, who took it over in 1872, capitalized on the growing public health interest in sea water and mud by using an inlet from the Salterns and advertising her 'strengthening sea baths'. They are now owned by Lymington and Pennington Town Council and in 2016 were extensively renovated.

The present-day Six Bells pub in St Thomas Street is run by JD Wetherspoon. The original pub, also named Six Bells, stood next door to this one until 1911 and was the

Lymington Sea Water Baths.

headquarters of the bell-ringers from St Thomas' Church. Another Lymington eatery, The Elderflower Restaurant, was featured on BBC Two's *Remarkable Places to Eat*.

The London 2012 Olympic gold medallist Sir Ben Ainslie (b. 1977) is a member of the Royal Lymington Yacht Club and has lived in the town. There is a gold-painted postbox on Lymington's High Street in his honour. It was originally painted by a local bar and bistro owner who felt it should be gold like other postboxes which had been painted by Royal Mail. Eventually it was decided it should indeed stay gold.

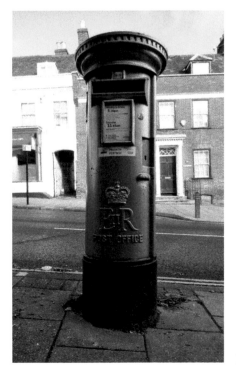

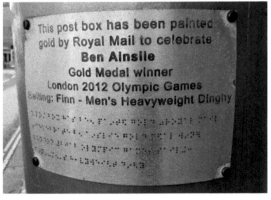

Ben Ainslie gold postbox in Lymington High Street.

In 2021 Sir Ben, who currently lives on the Isle of Wight, was awarded the honorary freedom of the private Beaulieu River, joining a select group including Sir Chay Blyth and Sir Francis Chichester.

The yacht *Kingfisher*, in which Ellen MacArthur took second place in the 2000/2001 Vendee Globe single-handed race around the world, was designed by Humphrey's in Lymington. Admiral Sir Harry Burrard-Neale (1765–1840) was a Lymington MP for twenty-seven years. He gifted Lymington with columns for the installation of gas lamps in 1832. A memorial lamp inscribed with the details of the event was erected at the Town Hall. Today it is by the Royal Lymington Yacht Club on the quay.

Pennington was once called Donkey Town due to the large number that roamed on the Common. Commander Peter Ouvry, who lived at the 'Salterns', was the first person to dismantle a magnetic mine in the Second World War.

King's Huts are six cottages in the shape of a horseshoe. Sir Edwin Luytens advised on the project. He is best known for designing the cenotaphs in Southampton, Whitehall, London and planning much of New Delhi in India.

Admiral Sir Harry Neale helped bring gas lighting to Lymington.

Hurst Castle

Hurst Castle was originally built by King Henry VIII between 1541 and 1544, using stone from Beaulieu Abbey. It was to guard the Needles Passage, the narrow western entrance between the Isle of Wight and the mainland. The castle was used for searchlights during the First and Second World Wars.

King Charles I was imprisoned at Hurst Castle before he was taken to London, tried and then beheaded in 1649. Father Paul Atkinson, the last Roman Catholic priest to be held under the Recusancy Act, was held there from 1700 to 1729 in solitary confinement having refused to attend Church of England services.

Barton on Sea

Barton on Sea gives its name to a type of fossil found in its cliffs. The Ashmolean Museum, Oxford, has a collection of locally found palaeolithic tools.

Links golf started on the clifftop with a nine-hole course in 1897.

Marconi conducted some of his radio experiments from 70 Sea Road.

DID YOU KNOW?

Children's writer Elizabeth Goudge (1900–84) once lived in Barton Lane. J. K. Rowling identified Goudge's Little White Horse as a direct influence on her Harry Potter books.

From 1914 until 1916 Indian troops played a vital role in helping to stem the German advance into Belgium and France. The sick and wounded were brought back to England. In Milford and at Barton, hotels were commandeered and used as convalescent homes for the Indians. Newspapers reported that over 250 guests were turned out of the Barton Court and Grand Marine hotels when the army commandeered them.

A monthly magazine, *Barton Breezes*, was produced. An article in the *Daily Graphic* dated 22 January 1915 gives an account of a concert put on for the benefit of the Indians entitled 'The West Entertains the East. Indian Troops at a New Forest Concert'.

The first award of the Victoria Cross to an Indian Army soldier was given to Sepoy Khudadad Khan for his action in Belgium on 31 October 1914. He was left for dead by German attackers but managed to crawl back to British lines. He recuperated at Barton.

On 10 July 2018 the Mayor of New Milton accepted a ceremonial Kirpan sword presented by the Sikh Council of Hampshire as a token of thanks for the warm welcome given to Indian soldiers in Barton on Sea and New Milton.

DID YOU KNOW?

Barton on Sea is the second most searched for village in the UK on Right Move.

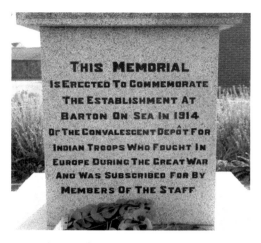

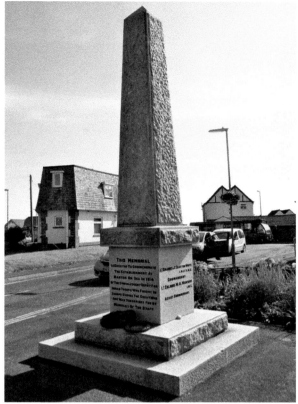

Above and right: Indian troop convalescent depot memorial, Barton on Sea.

DID YOU KNOW?

The boundary between Hampshire and Dorset was changed in a 1974 reorganisation. Hinton Admiral railway station stayed in Hampshire even though Highcliffe that it serves is now in Dorset.

Christchurch

Christchurch on the south-western edge of the Forest was once known as Twynham from its position between the waters of the Avon and Stour.

Christchurch Priory stands on the site of a Saxon monastery. Legend says an extra workman had been seen on site. One day a roof beam had been cut a foot short and left overnight. The next morning it was long enough to span the walls. Some said that the extra workman was the Carpenter of Nazareth and so the name Christ's Church came to replace Twynham.

A local specialised cottage industry was the making of 'fusee' chains used in watchmaking.

8. Characters of the Forest

Alice in Wonderland

The Alice in Wonderland stories have an enduring appeal across the generations. Alice Pleasance Liddell (1852–1934) was the young girl who inspired Charles Dodgson, better known as Lewis Carroll, to write *Alice's Adventures in Wonderland* in 1865, followed by *Alice Through the Looking Glass* in 1871.

The stories were first created on 4 July 1862 while Dodgson was entertaining the three Liddell sisters during a boating trip. Alice then lived at Christ Church College, Oxford, where her father was the Dean and Dodgson was a maths tutor. During a family holiday on the Isle of Wight, Alice met the photographer Julia Margaret Cameron who was part of a local bohemian circle, including the poet Alfred Tennyson, actress Ellen Terry and artist George Frederic Watts. Cameron photographed Alice Liddell and her sisters several times. The photographs are on view at Dimbola Lodge, Freshwater.

In 1880, Alice married Reginald Hargreaves, who had inherited the Cuffnells country estate, near Lyndhurst. The grave of Mrs Hargreaves is in the High Victorian Gothic-style church of St Michael and All Angels, Lyndhurst.

In 1928, financial hardship forced the widowed Alice to sell the manuscript given to her by Dodgson to an American collector. She was consulted on a Paramount film adaptation of the story, released in 1933. In 1948, the original manuscript was returned to the UK.

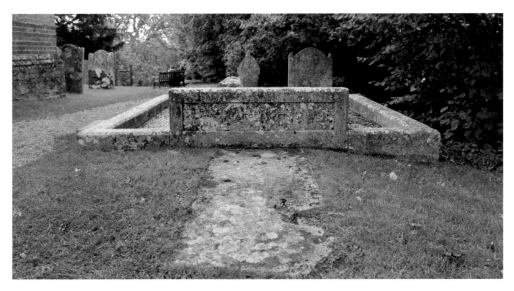

Alice's family grave.

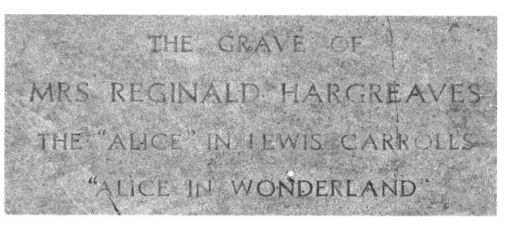

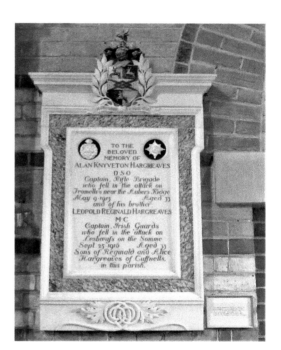

Right: Alice's two sons died in the First World War.

Below: Plaque in St Michael's and All Angels in Lyndhurst.

This memorial commemorates two sons of Reginald and Alice Hargreaves. Alice Hargreaves (nee Liddell) was the inspiration for Lewis Carroll's famous book Alice in Wonderland. The Hargreaves home was Cuffnells (now demolished) and the simple family grave is in the churchyard outside the south transept.

New Forest Shakers

In 1957 Jerry Lee Lewis sang that there was a 'Whole Lotta Shakin' Going On' in his rock and roll hit tune. Earlier Mary Ann Girling (1827–86) had arrived in the Forest in 1872 leading the 160-strong Children of God sect at Hordle, known as the New Forest Shakers. 'Mother' Girling claimed to be 'Jesus, first and last'. In 1864, she first claimed to be the reincarnation of Christ in a female form, having had five visions of Jesus and carrying the stigmata to prove it. This was disproved during her final illness.

The Victorian press often covered her story. This mother of ten, of whom only two survived, said that the second coming of Christ was imminent and that anyone who believed in her would live forever. They led an austere and celibate life. Day-trippers came from Southampton and Bournemouth to watch the Shakers dancing, or simply to mock or stare. Financial problems meant the group were evicted in December 1874 and by 1886 there were only twelve women and eight men left. Mary Ann is buried in All Saints churchyard, Hordle, along with others of her group, all without headstones.

James Seton

The last British man to die in a gun duel on English soil was James Seton (1816–45) St Mary's Church in Fordingbridge has a memorial to him. The duel was over the wife of Lieutenant Henry Hawkey with whom Seton was involved.

Seton was a wealthy man thanks to inherited money, with no need to work. In 1845, Seton met Isabella Hawkey, the wife of Lieutenant Henry Hawkey, an officer of the

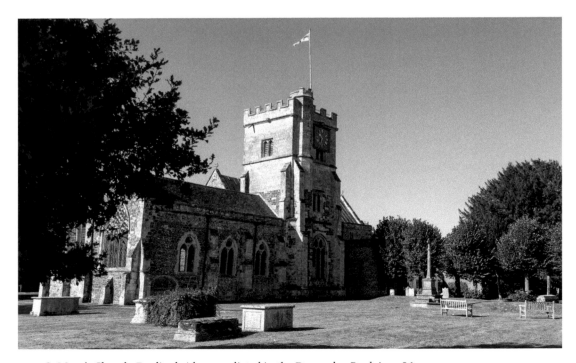

St Mary's Church, Fordingbridge, was listed in the Domesday Book in 1086.

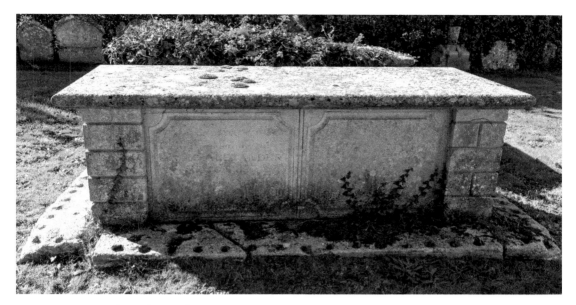

James Seton is buried in the family tomb.

Royal Marines, visiting her when her husband was absent. Henry Hawkey forbade his wife to see Seton. The Hawkeys and James Seton attended a ball in the King's Rooms, Southsea. There, James danced with Isabella. There was an altercation in which Hawkey called Seton a 'blaggard and a scoundrel'. After a pistol duel on 20 May, Seton died of complications from his wound on 2 June 1845. Hawkey was tried for murder but acquitted.

Brusher Mills

Do you recall the man with a bundle of brushwood on his back featured on the cover of the 1971 Led Zeppelin IV album? This man is said to be Henry, aka Harry, 'Brusher' Mills (1840–1905) who lived in an old charcoal burner's hut near Hollands Wood, sleeping on a sack of oak leaves and moss. Brusher Mills most likely acquired his nickname from brushing the cricket ground at what is now the Balmer Lawn Hotel or may be from clearing the ice for skaters at Foxlease Lake.

Mills caught thousands of snakes, selling the skins as souvenirs. Adder fat would be melted down to produce an embrocation for sprains and bruises.

Uncle Albert

Remember Uncle Albert in *Only Fools and* Horses? He was played by Harry 'Buster' Merryfield (1920–99). He was an Army fitness instructor during the war who took training runs around Southampton Common. Later, he lived in Verwood and I once spoke to him in Burley where he was promoting his autobiography. The inscription on his grave in Verwood cemetery reads: 'He lived for those he loved and those he loved remember him.'

Judge Jeffreys and Alice Lisle

In the late 1600s the infamous 'Hanging Judge' Jeffreys was feared. A pub's name at Rockford recalls Dame Alice Lisle (1617–85), the last woman to have been publicly beheaded in England in 1685 after a trial by the notorious judge. Alice grew up at her family's estate of Moyles Court.

Moyles Court is now an independent day and boarding school.

The Alice Lisle pub at Rockford.

At the age of nineteen she married John Lisle, who was an opponent of King Charles I and sat in the Long Parliament during the English Civil War. After Charles II was restored to the throne, John was assassinated in 1664, leaving Alice with seven children to raise.

In 1685 Alice was arrested for harbouring a Nonconformist minister, John Hicks, and Richard Nelthorpe at Moyles Court. Nelthorpe was a member of the defeated army led by Crown contender the Duke of Monmouth. Charged with treason, Alice was tried in Winchester on 27 August 1685 by Jeffreys. She said she had merely opened her doors 'to the hungry, the naked and the poor'. Originally sentenced to be burnt at the stake, this was later changed to beheading on 2 September 1685. This was considered a kinder death for a lady of her social standing.

The night before her execution she stayed in the Eclipse Inn in Winchester with the scaffold outside. Her body was taken home to Ellingham Church.

Florence Nightingale

'The Lady with the Lamp' making the rounds of wounded soldiers at night became an icon of Victorian culture. Florence Nightingale (1820–1910) lived in Embley Park, Wellow, on and off from 1825 until 1896. It was there in 1837 she had her Christian calling to her nursing work.

In 1896 when Embley was sold she said, 'I don't like being turned out of Hampshire.'

The offer of a burial at Westminster Abbey was turned down. The St Margaret of Antioch Church at East Wellow, dating from 1216, has the grave of Florence Nightingale with its simple inscription 'F.N.1820-1910', in accordance with her wishes.

In recognition of her pioneering work, the Nightingale Pledge is taken by new nurses. The Florence Nightingale Medal, the highest international distinction a nurse can achieve, was named in her honour and the annual International Nurses Day is celebrated on her birthday.

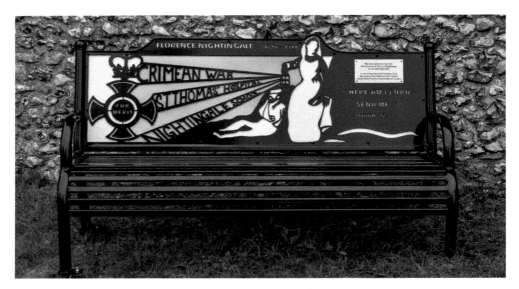

Florence Nightingale seat at St Margaret's Church, East Wellow.

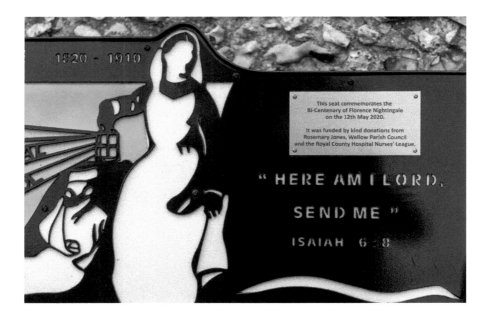

A simple inscription for Florence Nightingale who lived to ninety years of age.

9. New Forest Artists and Writers

Parts of the Forest can still feel like stepping back into a bygone age. Many talented people have been attracted here to find the space and inspiration to be creative.

Ken Russell

The Southampton-born film director Ken Russel (1927–2011) is best known *for Women in Love*, *The Devils*, and *Tommy*. He lived in a thatched cottage in East Boldre from 1972 until it was damaged by fire in 2006.

Augustus John

In Fordingbridge there is a statue of the bohemian artist Augustus John (1878–1961) who is said to have fathered over 100 children, including one with writer Ian Fleming's mother. He lived in Fryern Court from 1928 up until his death.

In 1908 Virginia Woolf regarded him as the best artist in Britain. His subjects included T. E. Shaw – better known as Lawrence of Arabia – and George Bernard Shaw.

Bronze statue of Augustus John.

The painter was also highly regarded by Hampshire gypsies, who called him Sir Gustus. As President of the Gypsy Lore Society, he fought for their right to travel and settle wherever they liked.

Juliette de Bairacli Levy

Known as the 'grandmother of herbalism', Juliette de Bairacli Levy (1912–2009) once lived with her two children in a tiny cottage at Abbots Well, near Frogham, and recounted her experiences in *Wanderers of the New Forest* (1958), such as daily naked bathing in Windmill Hill Pond. Like the artist Augustus John, she had a strong bond with the local gypsy community. Up until 1926 gypsies were able to camp freely in the Forest provided they moved on every twenty-four hours. After 1926 they were put into compounds such as Shave Green.

DID YOU KNOW?

Lucy Kemp-Welch (1869–1958) sketched Forest ponies when young and became the leading horse painter of her time. *Colt-Hunting in the New Forest*, her best-known work, is in the Tate Gallery. She illustrated *Black Beauty* by Anna Sewell.

Coventry Patmore

Coventry Patmore (1823–96) lived in Lymington in later life and is buried there. He is best known for his 'The Angel in the House' poem about the Victorian ideal of a happy marriage. It symbolizes the Victorian feminine ideal, which was not necessarily the ideal amongst feminists of then or any period. The term 'angel in the house' came to be used in reference to women who embodied the ideal of a wife and mother who was selflessly devoted to her children and supportive to her husband.

Dennis Wheatley

Best-known for his book about the occult, *The Devil Rides Out*, Dennis Wheatley (1897–1977) moved into Grove Place in Lymington in 1945 and left in 1968. His author's note about the dangers of dabbling in the supernatural ensured it became a sure-fire hit. As a member of Churchill's planning staff, he came up with the 'Monty's Double' plan.

Sir Arthur Conan Doyle

At All Saints Church, Minstead, lies Sir Arthur Conan Doyle (1859–1930), the author of the Sherlock Holmes stories. In 1955, when the Crowborough estate grounds in Sussex were sold out of the family, he and his wife's remains were re-interred at Minstead. Although allowed to be re-buried on hallowed ground, he was placed at the graveyard's southern end, as far as possible from the church because of his strong belief in the supernatural. Some say he is buried standing up as he was at Crowborough.

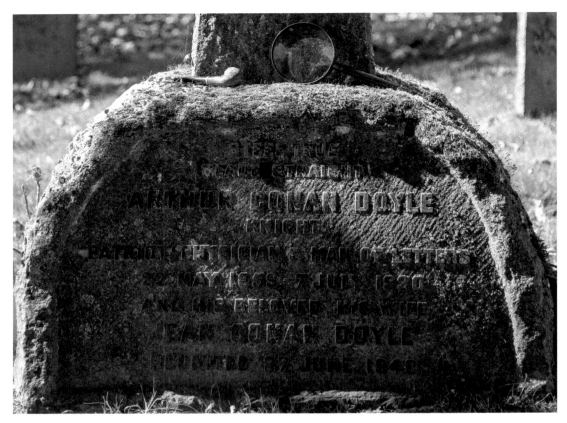

A pipe and magnifying glass is always on the grave of Sherlock Holmes's creator Arthur Conan Doyle.

In 1912, he turned to architecture to remodel the east wing of the former Lyndhurst Park Hotel to show the soul's journey to a higher place.

While researching *The White Company*, said to be his favourite work, he used the Montagu Arms Hotel in Beaulieu as his base and Doyle discovered the Forest. This led to him buying a country home, Bignell Wood, near Minstead, as a birthday present for his second wife, Jean. The house had a séance room for Arthur's spirit guide, Pheneas. Charles Dickens 'came through' saying he regretted not finishing *The Mystery of Edwin Drood* and suggesting that Arthur complete it. He also claimed that Joseph Conrad 'contacted' him asking him to finish the incomplete *Suspense*. Conan Doyle finished neither work.

Frederick Marryat

The adventure novel *The Children of the New Forest* by Frederick Marryat (1792–1848) was first published in 1847. It follows the fortunes of four children during the English Civil War and the Commonwealth. Frederick would sometimes travel to Hampshire to stay at his brother George's country house, Chewton Glen, now an upmarket hotel, to gather material for his book.

Mary Braddon

One of the New Forest's most celebrated nineteenth-century residents was Mary Braddon (1837–1915). She was a prolific writer and the founder of a new school of 'sensational' fiction. Writing as M. E. Braddon, the one-time actress produced at least eighty novels as well as plays, poems and short stories. Her most famous work was *Lady Audley's Secret* (1862), which made her rich and famous.

She and her husband, the publisher John Maxwell, had a home built at Annesley House, Bank. Mary Braddon's home even featured in sight-seeing charabanc tours of the New Forest. The couple provided public reading rooms at Bank and nearby Emery Down.

William Henry Hudson

The Anglo-Argentine author, naturalist and ornithologist William Henry Hudson (1841–1922) wrote *Green Mansions* in 1908. It was made into a 1959 romantic film starring Audrey Hepburn. He lived at Roydon Manor, Brockenhurst, around 1902. He published *British Birds* in 1895 and wrote *Hampshire Days* in 1903 whilst staying at the seventeenth-century Roydon Manor. Hudson recalled river walks 'by the Boldre, or, as some will call it, the Lymington, a slow, tame stream in summer, invisible till you are close to it'. His *A Shepherd's Life* describes the hard life of Shepherd Bawcombe around Breamore.

An early member of the Royal Society for the Protection of Birds, the Hudson Memorial Bird Sanctuary in Hyde Park includes a carved stone memorial by Sir Jacob Epstein representing Rima, the child goddess of nature, who featured in Hudson's novel *Green Mansions*. Ernest Hemingway referred to Hudson's *The Purple Land* in his 1926 novel *The Sun Also Rises*.

George Heywood Maunoir Sumner

George Heywood Maunoir Sumner (1853–1940) was a painter, illustrator and craftsman who was involved with the Arts and Crafts movement. In his mid-forties he relocated to Cuckoo Hill, near Fordingbridge, and spent his life investigating and recording the archaeology, geology and folklore of the Forest. In 1910 Sumner published the handwritten *The Book of Gorley*. Sumner illustrated his collection of eleven Hampshire folk songs, entitled *The Besom-Maker and other Country-Folk Songs*. *A Guide to the New Forest* (1923) is still a useful guide to the Forest woods.

Today Heywood Sumner House is a care home supporting up to twelve male residents of various ages with learning disabilities.

Philip Klitz

Born in Lymington, his family having emigrated from Prussia, Philip Klitz (1790–1855) collected local stories, poems and legends. In 1850 he published *Sketches of Life, Character and Scenery in the New Forest*.

Francis Edward Wintle

The pen name for Francis Edward Wintle is Edward Rutherfurd (b. 1948). His books have sold more than fifteen million copies and have been translated into twenty languages. The Salisbury-born historic novelist has written novels set in many different places around the world. *The Forest*, published in 2000, he has described as 'my happiest book'.

DID YOU KNOW?

Novelist Nevil Shute (1899–1960) based parts of his wartime adventure story *Requiem for a Wren* (1955) on his time at Exbury House during the Second World War.

10. The New Forest and War

Many would not initially associate the beauty of the Forest with the perils of war but there are many connections.

Napoleon, Nelson and Cornwallis

Napoleon had to gain naval control of the English Channel to execute his invasion plans, saying 'Let us be masters of the Channel for six hours and we are masters of the world.'

Admiral Cornwallis (1744–1819), as Commander in Chief of the Channel Fleet, dispatched to Spanish waters the nucleus of the fleet that his friend Nelson was to command at the Battle of Trafalgar. He was popular with his men, such that when he changed ship, his crew would ask to go with him. He is buried at Milford on Sea in the twelfth-century All Saints Church. He is in an unmarked grave with his friend Captain John Whitby who served on many of his ships. Milford has a Cornwallis Road and a Whitby Road.

At the time, Napoleon's plan to invade England involved 167,000 men sailing in 2,400 vessels. But first he had to move his fleet out of Brest. On 16 June 1795 Cornwallis was in command of a small squadron that sighted the much larger French fleet near Brest. The ensuing action became known as 'Cornwallis's Retreat'. He had five ships and two frigates to combat a French fleet of twelve ships and fourteen large frigates. Cornwallis pretended to signal over the horizon to non-existent support. The French promptly withdrew.

After Cornwallis had nursed Nelson during a fever Nelson wrote to him, saying, 'I never, never shall forget that to you I probably owe my life, and I feel that I imbibed from you certain sentiments which have greatly assisted me in my naval career – that we could always beat a Frenchman if we fought him long enough.'

Immortal Seventh

The 'Immortal Seventh', troops from the British Expeditionary Force, were stationed at Lyndhurst at the start of the First World War and put through their paces in replica trenches. In October 1914 they marched the 8 miles to Southampton and embarked for France and Belgium, where they went straight into the first Battle of Ypres. There is a commemorative plaque at the Offices of the New Forest District Council at Lyndhurst.

Lumberjills

In the First World War around 230,000 tons of wood were felled. A Canadian Timber Corps unit worked with Portuguese labourers and locals. The Portuguese Fireplace is around 2 metres tall and wide on the site of a First World War Portuguese camp.

The Portuguese fireplace from the cookhouse was retained as a memorial.

During the Second World War timber production increased to 440,000 tons. This was due in part to Lumberjills recruited to replace the men who had joined the forces. This was the name given to the nationally 8,700-strong Women's Timber Corps. Some of them worked harvesting timber for local sawmills such as at Denny Wood. Home-produced timber was urgently required for everything from railway sleepers to telegraph poles to coffins. It was 2008 before the Lumberjills received a badge for their role.

DID YOU KNOW?

In the First World War the Forest supplied heather used for packing munitions and thousands of acorns to produce acetone, a key component of cordite used in shells.

DID YOU KNOW?

A flying school on Beaulieu Heath near East Boldre was acquired by the War Department and Calshot became an air base.

Hospitals

Hospitals were established around Brockenhurst to treat injured soldiers, often from the British Empire.

During the First World War Balmer Lawn Hotel and its surrounding land was donated to the war effort by Mrs Morant of Brockenhurst Park and it formed part of the Lady Hardinge Hospital for wounded Indian soldiers between 1914 and 1915. Balmer Lawn and Forest Park Hotels were fitted out as medical facilities and Morant Hall, also called New Forest Hall, was transformed into another medical facility known as Meerut Indian General Hospital.

The No. 1 New Zealand Hospital opened on 29 June 1916 at the Balmer Lawn Hotel. Moss to dress First World War wounds was collected by Brockenhurst junior schoolchildren. In the Second World War it was used as the HQ for the Canadians and a commemorative maple tree was planted in the grounds.

During the Second World War, the Beaulieu estate was used for training agents by the Special Operations Executive (SOE) called 'Churchill's Secret Army'. Around 40 per cent died including Violette Szabo whose story was made into the film Carve Her Name with Pride starring Virginia McKenna.

New Zealand graves in St Nicholas churchyard.

Casualties of War

St Nicholas Church, Brockenhurst has a stained-glass memorial window, a gift from the New Zealand government and UK-based community. In the cemetery are the graves of more than a hundred New Zealand, Indian and other soldiers who died in local hospitals during and after the First World War. The memorial cross was erected in 1927 and an annual ANZAC memorial service is held here on the fourth Sunday in April.

Samuel Kinkead (1897–1928) was said to be the finest junior officer in the RAF; he was a member of the team that won the 1927 Schneider Trophy race in Venice. His Gloster IV reached 277.18 mph, the fastest biplane seaplane flight ever recorded. In 1928 he attempted to break the World Speed Record in a Supermarine S.5, ancestor of the Spitfire. On 12 March, his plane crashed into the sea. He was killed instantly and is buried

In memory of Flight Lieutenant Kinkead.

in All Saints churchyard, Fawley. A room in the Calshot Activities Centre is named after him. It seems fitting that a Spitfire plane was named The New Forest.

On the western boundary of the wartime airfield of Holmsley South is a memorial dedicated in 2002. The inscription says it is to 'commemorate the immense effort and sacrifices made in this area during the dark days of World War Two'.

The Forest as Training Ground

During wartime the Forest was also used for firing ranges, tank training, troop manoeuvres, searchlight sites, POW camps and more. However, perhaps the Forest's main contribution during wartime was by the twelve New Forest airfields, which brought home thousands of prisoners of war and service personnel and supported the operations of secret agents and Resistance organisations in occupied Europe. The biggest were at Stoney Cross, Holmsley, Ibsley and Beaulieu Heath. Only one survives, at Hurn, which has become Bournemouth International Airport. At Stoney Cross a stretch of road known as the Straight Mile follows the line of a runway. The US Army Chief of Staff, General Eisenhower, flew to Germany from Stoney Cross.

The 5,000-acre Ashley Walk Bombing Range site, behind 9 miles of security fencing, near Godshill saw bomb testing. It was under the direct control of RAF Boscombe Down based at Amesbury which was home to the Airplane and Armament Experimental Establishment. In the First World War an 80-pound bomb was considered large and we

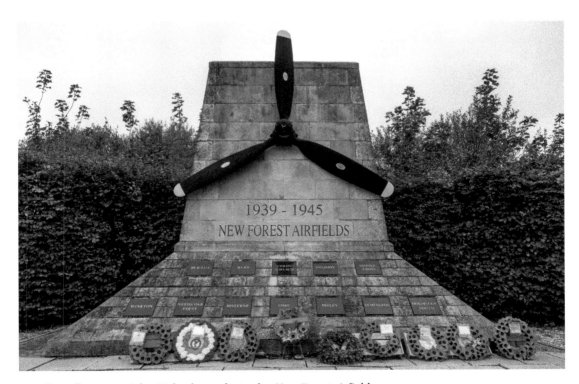

Propeller memorial at Holmsley to the twelve New Forest airfields.

needed to catch up with the superior weaponry being used by the Luftwaffe. Sir Barnes Wallis carried out developmental tests of his 'bouncing bomb' used by 617 Squadron in the 'Dambuster' raids in Germany. Also tested was the 12,000-pound Tallboy which was used to sink the *Tirpitz*, the pride of the German Baltic fleet.

In March 1945, Wallis live tested the 22,000-ton deep-penetration Grand Slam, also called Ten Ton Tess. It remains the largest bomb ever exploded on British soil. It was dropped from an Avro Lancaster and the crater it made was 140 feet wide and 70 feet deep.

DID YOU KNOW?

President Barack Obama (b. 1961) even has a link to the Forest. His maternal grandfather, Sgt Stanley Armour Dunham, served at RAF Stoney Cross and possibly at RAF Ibsley from April to July 1944. His ordnance unit supported the US 9th Air Force. Mr Dunham and his wife Madelyn cared for Barrack in Hawaii after his parents' marriage broke up.

DID YOU KNOW?

The film *First of the Few* (1942) telling the story of R. J. Mitchell and the Spitfire was partly filmed at Mockbeggar. Tin Town was the name given to the Nissen hut accommodation left by the RAF at Holmsley. It housed up to 400 people until closed in 1961.

During the period around D-Day, in June 1944, the 'Advanced Landing Ground' at Needs Oar Point was the busiest airfield in the country with 2,000 personnel on site and living in tents. With the pilots flying missions for up to eighteen hours a day the airfield saw an aircraft take-off or landing as often as one every forty-five seconds.

In addition to the Royal Air Force, units of American, Canadian, Polish, Australian, New Zealand, Russian, Norwegian, Dutch and Czechoslovak origin all operated from the New Forest. The fact that many local civilians, such as the NAAFI girls staffing the canteens, served alongside the servicemen and women is often overlooked. The Canadian war memorial is near Highland Water Inclosure.

The thin topsoils of the New Forest mean that runways, service roads and building foundations of some wartime airfields have never been fully reclaimed by nature. D-Day reminders can still be seen off the shores of Lepe Beach, where some large concrete platforms used to construct the famous 'Mulberry Harbours' still exist. On the lane out of the country park, some tank parking bays are still visible on the roadsides.

DID YOU KNOW?

Longdown and Denny Lodge were sites for starfish decoys to simulate a burning town and lure Luftwaffe bombers away from targets around Southampton. They were originally called Special Fire (SF) sites but the starfish name caught on.

Made It by a Whisker

RAF Ibsley had a ginger cat that nestled by the radio transmitter. The operators realised that it picked up signals before they did and would watch out for twitching ears and whiskers. High Frequency Direction Finding Stations, known as Huff-Duffs, were used to track Allied aircraft and help them to intercept enemy aircraft. Their towers were made of wood to reduce interference and housed the equipment and operators. One was near Ibsley Common where, one evening, Sandy Fraser was on duty. Suddenly, the ginger tom cat's ears started to twitch. The cat had ended up in his care when he took over the station and liked to sleep on the warm signal-generating set. Sandy decided to give the cat its own pair of headphones to help him pick up signals.

Sandy sent out a bearing signal. An American pilot in trouble picked up the signal, started to use it and eventually landed safely at an airfield in Exeter. Eventually, the cat stopped twitching and curled back up to sleep having just saved a life. The cat went to a good home after the war.

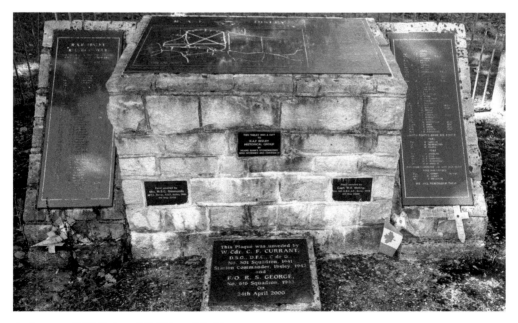

A plaque to RAF Ibsley airfield is at Mockbeggar.

11. New Forest Nature and Wildlife

Wildlife Presenters

Eric Ashby (1918–2003) lived in Linwood and worked on many BBC wildlife programmes. He once visited a badger site ninety times to record just one minute of film. It took four years for Eric to shoot enough sequences for his forty-five-minute BBC film *The Unknown Forest* in 1961. *The Major*, the life story of a village oak tree, was the first wildlife film to be shot in colour.

An ardent conservationist, Eric founded the first local Badger Group in 1969 and was outspoken in his views against hunting. His home became a haven for wild foxes from rescue centres. He told his story in a book, My *Life With Foxes* (2000), with a foreword by Chris Packham. Eric has a memorial bench at Fritham. Chris Packham (b. 1961), wildlife enthusiast and TV presenter, was born in nearby Southampton and today is a resident of the New Forest.

Plant Life

The Knightwood Oak near Bolderwood is over 500 years old, has a 7.4-metre girth and is an example of the former art of 'pollarding', the traditional way of harvesting wood without killing the tree.

Knightwood Oak direction sign.

Above: Eventually the Millenium Oak will replace the Knightwood Oak.

Right: The Knightwood Oak was there in the time of King Henry VIII.

Pollen analysis has shown that the Forest was first colonised by alder trees around 7,500 years ago, around the time the English Channel was formed. The Forest has twenty-five scarce plants such as wild gladiolus. All three types of heather are found; the dominant ling heather, bell heather found in dry areas, and cross-leaved found in wetter areas. About 2,700 types of fungi can be discovered.

Today the inclosure process is being reversed in places, with some plantations being returned to heathland or broadleaved woodland. However, invasive rhododendrons remain a problem.

Herbert Goodall started growing strawberries at Bamptons Farm in 1912 and it still opens every year. In autumn it sells pumpkins. Furzey gardens were opened to the public in 1930 and have an unusual 'Bottle Brush Tree'.

In 1986 the Minstead Training Project was established by Martin Lenaerts, a former Cistercian monk with a gardening vocation, working with five young adults with learning disabilities. It is run today as a social enterprise of local charity the Minstead Trust which supports over 200 people with learning disabilities. In 2012, Chris Beardshaw designed a gold medal-winning garden for the Chelsea Flower Show to show what people with learning disabilities can achieve.

Salt

Sea salt was produced around Lymington from Roman times to 1865, when Cheshire salt gained supremacy. The boiling pans were fired by coal brought in from the Newcastle area by barge. At the industry's peak in 1730 there were around 160 pans in the Lymington area.

The owner of some of the Lymington salt houses, Mr Charles St Barbe, made a profit of £25,000 – equivalent to £2.2 million today. Two Grade II-listed barns at Lower Woodside are the last surviving remnants of the salt trade.

The Lymington-Keyhaven Nature Reserve has a plaque which bitterly complains of 'a glaring injury to the beauty of the shore'. The words were written in 1791, by a vicar aggrieved by Hampshire's booming salt industry with its giant vats of brine, wind pumps and boiling houses spouting smoke. That vicar would have been very happy with his view now as the nature reserve creates an idyllic spot, home to rare flowers and nesting birds.

Today, St Barbe Museum tells the story of salt production.

Wildlife

The Forest is home to all six UK native reptiles: sand lizards, adders, slow worms, grass snakes, smooth snakes, and common lizards. If on a walk, watch out for the adder or viper, the UK's only venomous snake. It has a distinctive zigzag pattern on its back and can grow to 80 cms. All three UK species of newt are also found.

The Forest is also home to over 2,000 types of beetle. The rare stag beetles are protected by law. There are at least twenty-five types of ant and the southern wood ant creates huge nests made from pine needles, twigs and leaves. The medicinal leech can grow to 20 cm long, has three jaws and 100 teeth and is found in five water bodies in the Forest.

The Earl of Southampton established an ironworks at the 47-acre Sowley Pond in 1590 and it is the only local breeding site for damselflies. The Forest is home to 75 per cent of all species of dragon and damselflies and has the only cicada species native to the UK. The Forest has around half of the 2,500 types of butterfly and moth.

Hatchet Pond is home to 90 per cent of the rarest wetland plants in the UK, such as Coral necklace and Pillwort. The Forest has 75 per cent of the boggy areas or mires left in north-west Europe. They absorb carbon and prevent flooding further downstream. The River Lymington supports freshwater invertebrates such as stoneflies and mayflies. It is also home to a variety of fish such as the Brown Trout and the Bullhead.

Forest gorse, aka furze, is one of the few homes of the rare Dartford warbler with Dur Hill near Burley and Hampton Ridge near Frogham good spotting places. In the 1960s only a few pairs remained but today there are over 3,000 pairs.

Known as the 'phantoms of the forest', the goshawk is an elusive bird of prey. It nests in tall trees and the Forest has around forty pairs. Blashford Lakes has the protected Bittern bird. Males have a distinctive call or 'boom' that can be heard up to 5 km away.

The former large house at Tatchbury Mount is gone and today it is mainly an NHS administrative site. The Iron Age fort at the top offers good views and there is a bat sanctuary there. There are seventeen species of bat in the UK and most can be found in the Forest.

The forest has over 2,000 deer. There are five species – fallow, which are the most common; Japanese sika introduced in 1902; muntjac, which are rare; plus, the only two types native to Britain, roe and red deer, which are the UK's largest mammals. A male deer can reach 140 cm and weigh 190 kgs.

Recently a colony of oysters was introduced to Wightlink's terminal in Lymington by the Blue Marine Foundation. Oyster reefs are important as they filter the water, reducing the impacts of excess nitrogen, stabilise sediment and enhance fish production. These high-density populations release millions of larvae. The colonies, suspended in nurseries underneath pontoons, also provide a refuge for other marine life including critically endangered European eel, juvenile spiny seahorse and sea bass.

Pannage is when pigs are turned out in autumn to snuffle the acorns covering the forest floors, which are poisonous to cattle and ponies. Outside of the pannage season you may see pigs roaming the New Forest but these will only be females. Bramshaw and Bolderwood are where you will have the best chance of seeing the pigs during the pannage season. The pigs have rings in their nose to ensure that they can move the leaves and the other foliage on the forest floor to discover the acorns and nuts; it also prevents the pigs from digging into the ground.

Pine martens are chestnut brown cat-sized members of the weasel family. They are now breeding again, with video evidence first recorded in 2016.

Ponies

Around 5,000 ponies wander freely over the Forest and all belong to someone. The ponies are described as the 'architects of the forest' and without them the area would soon become overgrown. The New Forest pony is today much in demand as a riding pony and is renowned for its sure-footedness and ability to carry weight. A 14-hand pony (a hand is 4 inches) can carry a stone for every hand, so a small pony could carry a 14-stone person. A pony is under 1.42 hands high – over that and it's a horse.

DID YOU KNOW?

Stallions are released in May across the Forest as part of a controlled breeding programme for up to eight weeks.

Every New Forest pony is marked with an individual brand. Their tails are styled in a certain way to show that their dues have been paid to the Verderers.

Roger Penny Way is one of the worst routes in the Forest for collisions involving ponies, sheep and donkeys. Despite a 40 mph speed limit in place since 1976, combating the number of livestock killed on Forest roads is one of the Verderers' chief concerns as ponies, donkeys and cattle have the right to freely roam.

After a 2021 petition, the introduction of average speed cameras on the route is a possibility. Around 100 free-roaming animals are killed or injured in the New Forest each year with around three quarters of the accidents involving local drivers. Back in 1953 there were ninety-one animal deaths, which is perhaps surprising given the lower volume of cars then. Animals have right of way on unfenced Forest roads. Some road signs now say #Add 3 minutes to encourage drivers to keep to the 40 mph speed limit. Some ponies are fitted with reflective collars to make them more visible at night.

Legend says that the ponies are descended from the jennets which swam ashore from the wrecks of the Spanish Armada. The ponies tend to stay in groups in the same area, known as their haunt. If a pony is stressed by humans, they put their ears back.

12. New Forest Ghost Stories

The New Forest may be one of the most haunted places in the country. In May 1924 three young people from Southampton were cycling just past the Bell Inn by Bramshaw golf course when they overtook a very tall pedestrian in a big top hat. Later they overtook him at Telegraph Hill and again at the Fritham and Nomansland crossroads. How had he managed to get ahead of them? Is this Tall Man just one of many such tall stories?

*

The Angel & The Blue Pig in Lymington has had many spooky sightings. Recurring apparitions include those of a coachman, an individual wearing a naval uniform, and there have also been the sounds of a piano playing.

*

A ghostly procession has been seen passing across the car park of the Hare and Hounds, Sway, on its way to the gibbet at Marlpit Oak where three highwaymen were once hanged. Folklore says that the highwaymen were also buried at the crossroads. The purpose was to confuse their departing souls so that they did not know which way to travel and could therefore find no peace.

*

Moyles Court, a seventeenth-century house now a school, was once the home of Dame Alice Lisle who was executed in 1685 for sheltering fugitives from Monmouth's rebellion. She has been seen with her head under her arm walking around the house and also in a coach drawn by headless horses and without a coachman.

*

In the churchyard at Breamore, two figures sometimes appear near a yew tree under which three stone coffins lie. The hooded forms then drift off slowly towards the mysterious mizmaze that lies in a clump of trees not far away. Once there they slowly vanish.

*

Breamore House is haunted by two generations of Doddington ladies who lived there in the 1600s. A portrait of the elder hangs in the house to this day, as on her deathbed she

threatened to put a curse on anyone who dared move it. A cleaner in the 1950s did move it and had a fall later that day, breaking his leg. Nobody has touched it since.

The younger Mrs Doddington was murdered by her son and now haunts the blue bedroom, where she died. Her ghost appears whenever there is a serious illness or death.

*

Burley is well known for its connections to witchcraft. The Coven of Witches shop is home to a ghostly cat who welcomes visitors. Another ghost is reported to ride past the tree on Burley Lawn where he was hanged back in 1759. He sits astride a brown horse and wears a smart suit with bright metal buttons.

Strange moans were regularly heard beneath the bar of the Queen's Head pub in the village. In the 1950s, renovation work revealed a long-hidden hatchway and tunnel where smugglers hid their goods from prying excise men. While no skeletons were found, the moaning instantly stopped.

*

A small weeping boy running along the track haunts the footpath at Picket Post near Burley. The child was alleged to have been drowned by a Burley couple.

The fourteenth-century Tudor Rose Inn, at Burgate near Fordingbridge, is home to a phantom cavalier. His most annoying habit is to knock on a door before entering, then slamming it violently behind him. A landlady has removed many of the doors.

*

At the White Hart in Ringwood a door also slams in the kitchen, no matter what is used to prop it open. Staff believe the building is haunted by the ghost of a chambermaid who is obsessed with keeping things tidy. An exorcism was carried out in the 1960s and a cross was carved in the wall by the stairs.

*

A double tragedy lies behind the haunting of the former Wagon and Horses pub at Walhampton. It is now named The Ferryman, a free house near Lymington Pier. In 1893, the body of a farmer was found lying in a local field. He had been shot in the back from a single blast from his own shotgun, although he had no enemies nor motive for killing himself.

The local gamekeeper, Henry Card, demonstrated how it would be easy for a person to accidentally shoot themselves if they were carrying the gun in such a way, then tripped and fell. Tragically, Card's gun was loaded and he shot himself in exactly the same manner as the farmer. He died instantly and his ghost has since been seen in the bar of the pub.

*

In Wellow there have been reports of a phantom coach and horses seen on New Year's Eve. There is even a plaque on a small stone seat where a bridge called the Sounding Arch used to be until 1966. The bridge connected two parts of the Embley Estate where Florence Nightingale lived.

*

A Bronze Age burial ground or barrow near Beaulieu known as Cold Pixies Cave may have been named after Colt Pixies who are said to take the form of a horse and lead the other horses into bogs. The site has never been excavated. During the quiet winter months, it has been used as a gathering place for white witches. If they do not perform a ritual at the site then an unquiet spirit will rise.

*

The White Hart is situated on the Cadnam to Copythorne road. If you pass through the doors and become aware of an overpowering aroma of perfume it is the Lady of The White Hart. The fragrance is followed by a drop in temperature. A landlord did say that a dormant clock started ticking once again when the lady approached.

*

In the 1970s, two sisters were staying at the High Corner Inn at Linwood. During the early morning one awoke to witness a middle-aged lady in period costume staring through a glass panel with her arms folded gazing towards the stables.

13. The New Forest's Future

The area has often faced threats to its unique way of life. Today some are concerned about the effects of tourism or second homes.

In times past, fears about inclosures to provide wood for shipbuilding prompted this anonymous rhyme. It still seems appropriate today:

The law doth punish man or woman
That steals the goose from off the common;
But lets the greater felon loose
That steals the common from the goose.